The RURALISTS

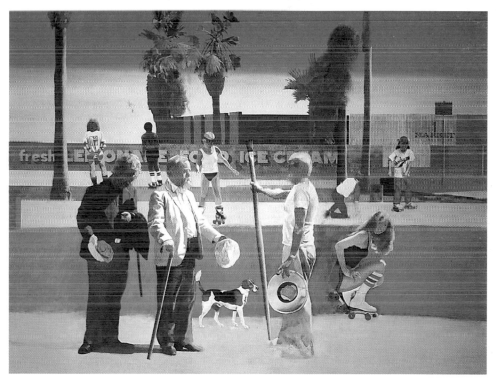

Peter Blake, The Meeting (Have a Nice Day Mr Hockney) , *1981-83, oil, 99.1x124.5cm*

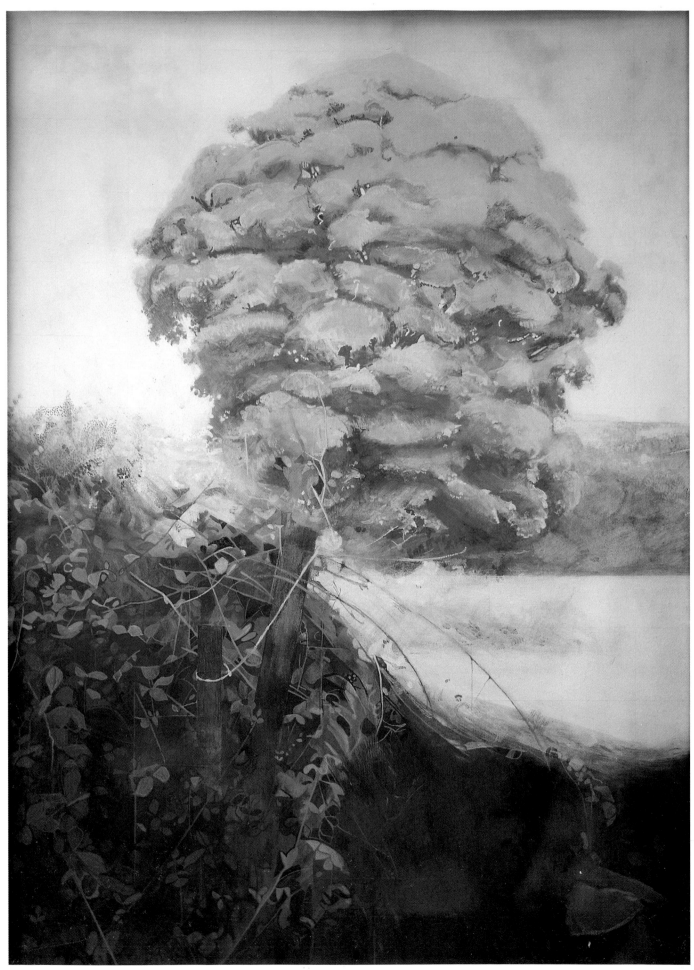

Annie Ovenden, Tree at Panter's Bridge, *1976, gouache, 49.5x34.2cm*

An Art & Design Profile
Edited by Andreas C Papadakis

The RURALISTS

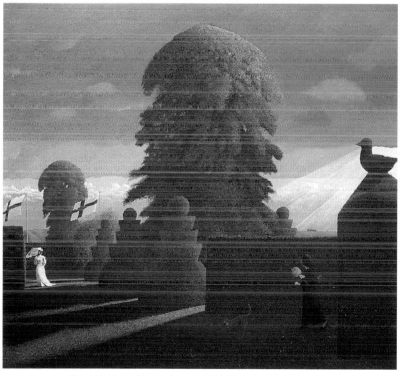

David Inshaw, Presentiment, *1973-78, oil, 142.2x198.1cm*

ACADEMY EDITIONS · LONDON

Acknowledgements

We would like to thank the Ruralists for their collaboration in producing this issue and the following galleries for providing material: Piccadilly Gallery, London, Waddington Galleries, London, Tate Gallery, London.

We are also grateful to the following for permission to publish written extracts:
Laurie Lee, Victor Arwas, Robert Melville, Clive Wainwright, *Graham Ovenden*, Academy Editions, London / St Martin's Press, New York.
Marco Livingstone, *Pop Art: A Continuing History*, Thames & Hudson, London, 1990, © Marco Livingstone.
Caroline Odgers, 'A move to the country: The Brotherhood of Ruralists', *Country Life*, 23 April 1981, pp1112-13.
Nicholas Usherwood, *David Inshaw*, Academy Editions, London / Brighton Museum & Art Gallery, 1978.
Nicholas Usherwood, *The Brotherhood of Ruralists*, Lund Humphries, London, 1981.
Marina Vaizey, *Peter Blake*, The Royal Academy Painters and Sculptors series, Weidenfeld & Nicholson, London, 1986.

Photo credits: Prudence Cuming Associates Ltd, p8, p23, pp26-27, p30, p53, p61, p80, pp83-87; John Webb, Tate Gallery London, p17; we are grateful to Roger Moss, Liskeard, Cornwall for contributing specially photographed images for this issue

EDITOR
Dr Andreas C Papadakis

EDITORIAL OFFICES: 42 LEINSTER GARDENS LONDON W2 3AN TELEPHONE: 071-402 2141
HOUSE EDITOR: Clare Farrow ASSISTANT EDITOR: Nicola Hodges DESIGNED BY: Andrea Bettella, Mario Bettella
ADVERTISING: Sheila de Vallée SUBSCRIPTIONS MANAGER: Mira Joka

First published in Great Britain in 1991 by *Art & Design*
an imprint of the
ACADEMY GROUP LTD, 7 HOLLAND STREET, LONDON W8 4NA
ISBN: 1 85490 123 0 (UK)

The Publishers and Editor do not hold themselves responsible for the opinions expressed by the
writers of articles or letters in this magazine
Copyright of articles and illustrations may belong to individual writers or artists
Art & Design Profile 23 is published as part of *Art & Design* Vol 6 9/10 90
Published in the United States of America by
ST MARTIN'S PRESS, 175 FIFTH AVENUE, NEW YORK 10010
ISBN: 0-312-072-643 (USA)

Printed and bound in Singapore

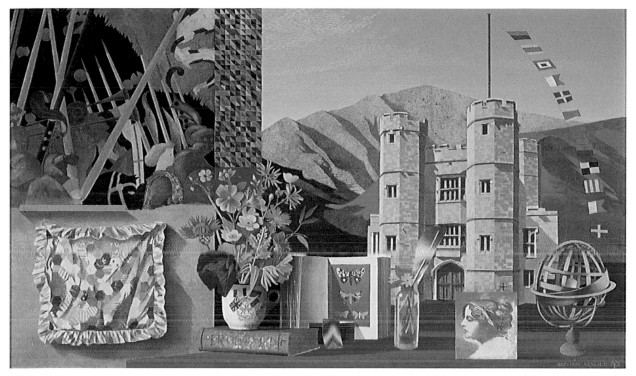

Graham Arnold, The Journey, *1986-88, oil*

Contents

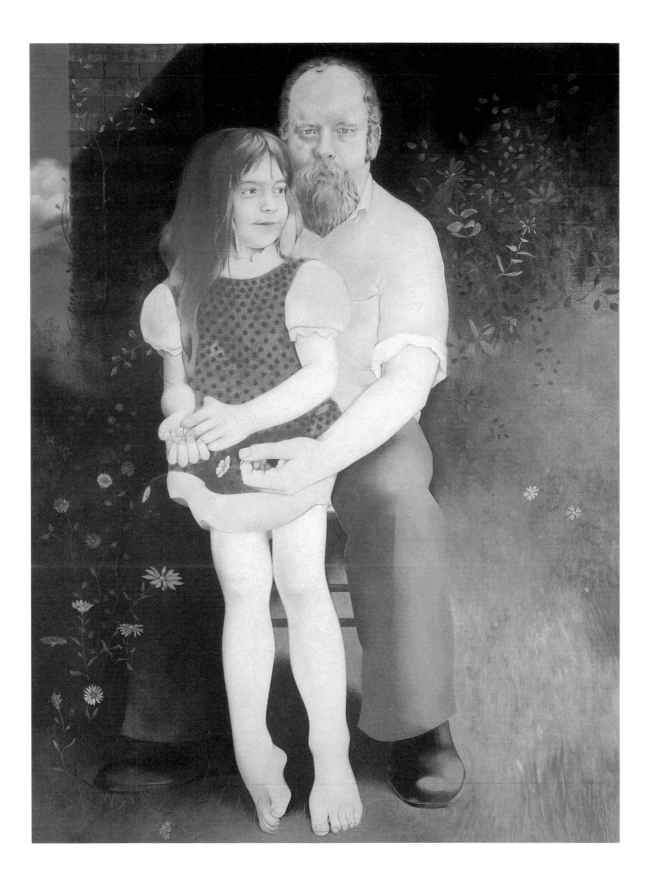

CHRISTOPHER MARTIN
IN THE SECRET GARDEN: AUTUMN WITH THE RURALISTS

One disarming thing about the Brotherhood of Ruralists is its manifesto. There isn't one. Or if there is no-one knows where it is. Most of the Brotherhood think that there probably is a manifesto. Didn't their friend John Michell, the 'new-age' writer, do something? Hasn't Peter Blake got a copy? Well yes, agrees Peter Blake, he thinks he might have a copy somewhere. He's going to look it out sometime. There again Graham Arnold has a reputation for squirreling things away. Is it going gently yellow in his Shropshire attic? Graham Ovenden down in Cornwall is a collector to the point of addiction; hasn't he got the manifesto?

No matter. The Ruralists are clear enough as to why the Brotherhood was founded, about what they wanted to achieve, what they stood for, what they stood against.

The fact that no furious document in the manner of the Futurists or the Vorticists seems to have survived in no way weakens the memory they have of the commitment and the exhilaration of those days in 1974 when a group of like-minded artists got together in the face of what they regarded as the desolate and crippling condition of English art and sought to do something about it.

The art schools – they thought – were dreadful, the gallery system pernicious, the critics ideologically motivated and ignorant, the museums and arts councils dominated by sinister coteries. London, city life in general, was best avoided. Consciously adopting a name which echoed the foundation in 1844 of the Pre-Raphaelite Brotherhood, they were also following some of its precepts. Ruskin had advised young artists, as he might have advised young Christian men to go to the mission fields, to go to nature; not just because it was a subject worthy of art but because of its moral value, because it was God's handiwork and so revealed His purposes. 150 years on the Ruralists see nature if not exactly demonstrating Christian morals and faith, as at least bathed in a divine light. In their more exalted moods they feel at one with their great and much invoked mentors William Blake and Samuel Palmer; seeing every hill, wood, blade of grass, blade of corn as invested with a spiritual presence; with, in the words of another of their heroes William Wordsworth,

A sense of something far more deeply interfused,

Whose dwelling is the light of setting suns

And the round ocean, and the living air,

And the blue sky and in the mind of man.

But the foundation of the Brotherhood was not as solemn an occasion as these august affiliations might suggest. The idea came up over a more than usually convivial meal and was agreed on, according to some who were there, half jokingly. In fact it meant different things to each of them. What it certainly gave to all of them was the strength of association.

It is hard now to imagine the contempt with which not only figurative painting but painting itself was held in the late 60s and early 70s. Exhibitions at the Hayward Gallery took as their starting point the demise of paint. Art was performance, numbers, concepts, documents, machines, photographs, maps, mud, piles of stone, piles of bricks. Art was there to shock and show its political credentials –

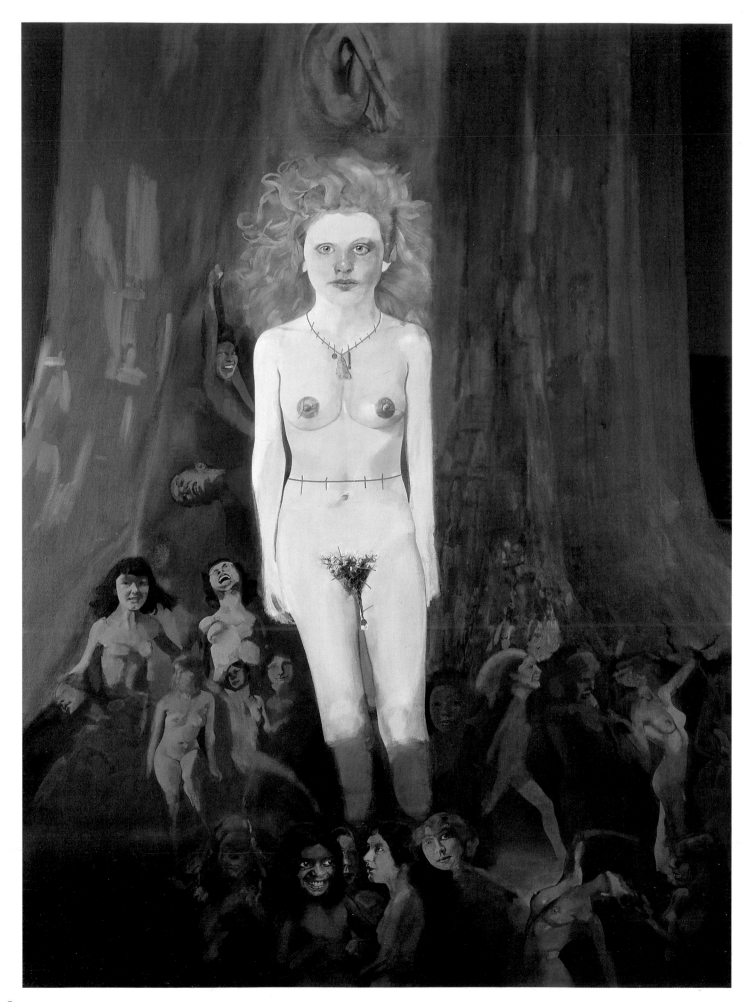

not to be beautiful, not to give pleasure or reassurance. What was needed, the Ruralists agreed, was a Sign. The Brotherhood would show the world that belief in the old values and the old skills of art was not dead and that their time would come again. The earthly paradise may still be some way off but nearly 20 years on the Ruralists, scattered and changed as they now are, meet up at each other's private views in a spirit of considerable satisfaction at the extent to which their stand against the then seemingly irreversible tide of modernism succeeded.

Peter Blake, Titania, *1976, work in progress, oil, 121.9x91.4cm*

Ann Arnold, The Brotherhood of Ruralists at Coombe, *1977, oil, 45x55cm*

Cork Street's Piccadilly Gallery is one place where, on sorties to London, they occasionally meet behind enemy lines, so to speak. At the joint shows or single exhibitions of their work that their great supporters Godfrey and Eve Pilkington put on at the gallery you can see them, pleased enough to be in London again but eyeing time-tables and looking at watches to check on last trains from Paddington to Cornwall, Shropshire and Wales. The Brotherhood was never a commune but its members once lived closer together.

As the circumstances of the Ruralists' foundation are vague, so too are the details of its supposed breaking up.

It is a matter of dispute whether in fact the Brotherhood has broken up. David Inshaw, one of the most enthusiastic of the founders, thinks it all came to a natural end a few years ago. People's marriages broke up. They moved away. Their style changed. If no formal obituary was ever issued that is because the movement is so manifestly no longer in business. But Graham Ovenden denies that it is all over and certainly new exhibitions bearing their name, publications, new projects suggest the vitality of rather more than an after-life.

One thing all the founding brothers were sure of was that they would be in for a great deal of stick from the critical establishment that they were defying. They were not disappointed. There's an early painting by Ann Arnold of them all posing as if for a holiday snap with their children in an orchard in Cornwall. It presents a cheerful picture of uncomplicated enjoyment both of the countryside in which they were all on holiday and of each other's company. A film made for BBC Television by John Read at much the same time presented a similarly relaxed and idyllic view of life with the Ruralists.

The film brought them and their artistic ideals to a large, general audience and the letters that followed transmission suggested strong support for both. But the image of sunny pastorale in which the artists seemed to live irritated the opposition almost as much as their theories and their paintings. The proper goals of art were not pursued in such congenial and escapist circumstances. If people felt they absolutely had to paint then the themes they should be painting were to be found not in the countryside but in the city – where the angst-ridden soul of 20th-century man was wrestling with its destiny.

But the most terrible accusation of all was that they were not 'Progressive'. They were 'Regressive'.

Graham Arnold liked the film but feels it did give a somewhat Elysian picture of Ruralist life. It was filmed, after all, when they were on holiday together. Life for the Ruralist artist, he remarks wryly, can be just as angst-ridden as it is for anyone else; there was plenty of gloom in their lives if that was required and this was doubtless reflected in their paintings. Arnold makes a comparison with Elgar, another Ruralist hero. Elgar did far more than write music that evoked the Arcadian nature of the English countryside but wrote works that convey unimaginable depths of anguish or spiritual ecstasy. So too, he says, do the Ruralists seek through their work to explore the range, the complexity – and the darker side – of human existence.

Nonetheless, the very fact of putting their heads above the parapet was enough to earn them some

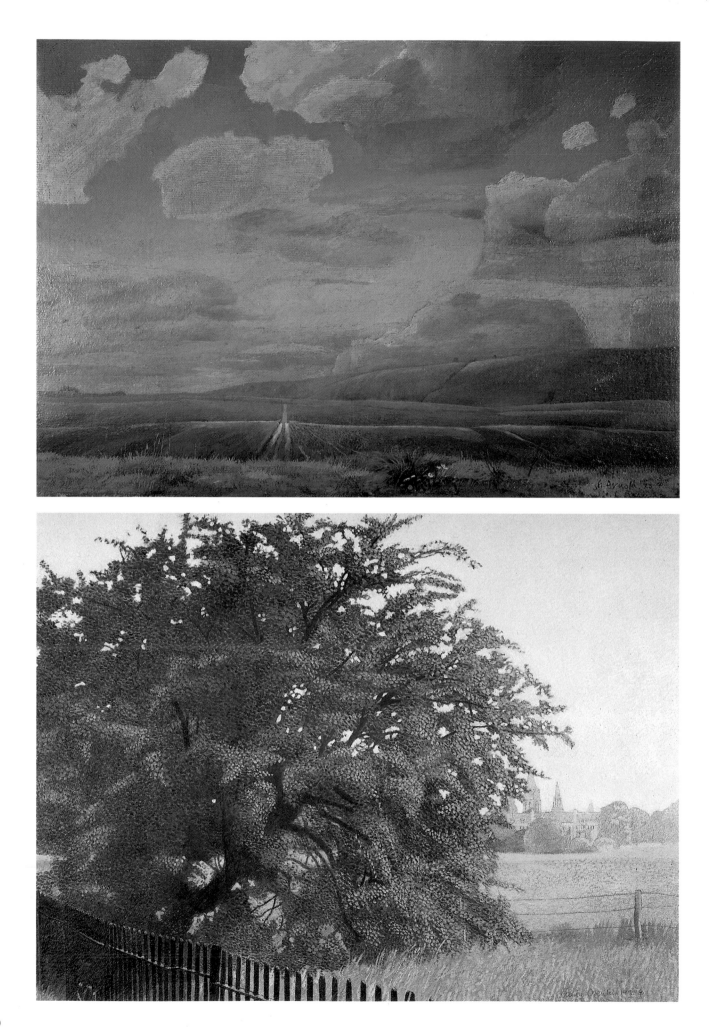

withering fire from the media. It was not, as I recall, based merely on disagreement with their aims and methods but derived in some cases from a hatred of their work that was almost pathological. Did they not impudently claim inspiration from artists so much their betters that the comparison between them was blasphemous? Did not some of them, Peter Blake in particular, paint fairies? Did they not, it was suggested darkly, show an almost morbid interest in children? Like the Pre-Raphaelites, the Ruralists had somehow put themselves in the vanguard by looking backwards – to a time before things in art had, as they saw it, gone terribly wrong.

They were quite aware of the dangers. Inshaw remembers being nervous of the consequences of submerging his own considerable name and reputation into that of a group. His fears were shared by Leslie Waddington, whose gallery dealt (and still deals) in his and Peter Blake's work. The flak that would undoubtedly fly after the formation of so unfashionable and intransigent a group might jeopardise all he had achieved. But it was worth it. Inshaw thinks the Brotherhood gave himself and the others stimulus, companionship, reassurance, and a sense of purpose in the directionless fog that then enveloped English art.

John Michell reminded me that they are artists, visionaries if you like, rather than thinkers; but he said their painting and technique were improved by the association with each other and by the act of shaping a common philosophy together.

The less famous members of the group tended to be the wives. Annie Ovenden was an illustrator. The Brotherhood gave her the confidence to have another go at painting. Like Ann Arnold's, her pictures hanging in the Royal Academy next to those of the most famous Ruralist, Peter Blake, attracted more attention than would have been likely in ordinary circumstances. Both the women's pictures were good enough to hold their own in grand company and both have become anything but second division Ruralists. Those who bought the work of either of them in those early days are lucky.

And it was great fun. All of them felt in some way that they were taking part in a piratical adventure. Instead of being the mute recipients of prejudiced and ill-informed criticism they were on the attack. A Futurist-type manifesto they may not have written but there was certainly an element of a call to arms about those early Ruralist shows. These toured the country – London, Bristol, Glasgow, Cambridge – drawing much public approval, satisfactory sales, and usually sneering dismissal from the critics. In 1983 Peter Blake had an exhibition at the Tate. Space was reserved in it for his Ruralist friends. It provoked one of Peter Fuller's most vitriolic reviews. ('What Blake and his fellow "Ruralists" have never understood is that the tradition they so glibly evoke would have despised them . . .') It sometimes seemed that critical integrity was measured by the extent of the critic's disapproval.

And yet they certainly had supporters. Poet Laurie Lee wandered into the Piccadilly Gallery and was entranced by a one-man show of Graham Ovenden's. Critic Robert Melville wrote appreciative and perceptive reviews of Ruralist work. Even Peter Fuller, whose own journey from Marxism to a point of view that was, in theory at any rate, not unlike that of the Ruralists, made some sort of rapprochement with Peter Blake, who wrote for Fuller's magazine Modern Painters before the critic died. The Ruralists themselves have developed thick skins – or they affect indifference to the barbs and the almost equally dismissive silences that customarily greet their work. They now look back with relative tranquillity to those early, pioneering days.

Oddly enough two artists, John and Diana Morley, who never became fully paid-up Ruralists themselves, remember most vividly the circumstances that surrounded the Brotherhood's foundation. John Morley doesn't feel like the fifth Beatle exactly but he is conscious of something happening of

Ann Arnold, Wiltshire Landscape, *1983, oil*

Annie Ovenden, Christchurch from the Watermeadows, *1990, oil*

11

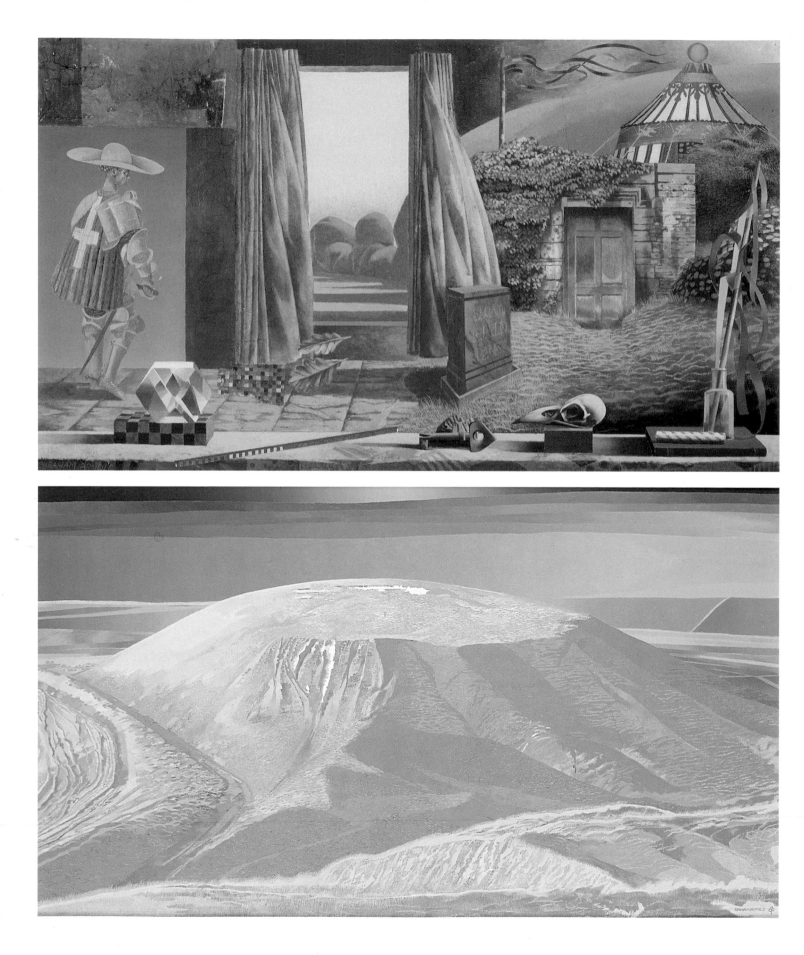

which he might have been a part and wasn't quite. He'd known Graham Arnold since Arnold had taught him at school. When Morley went to art school at Beckenham, Arnold was teaching there too. They were by then already friends. Morley's style, in the early 50s, was studiously traditional and as such was thought by the college authorities to be having a contaminating effect on the other students. He was thrown out of Beckenham but Graham Arnold's references got him into Bromley.

He remembers Graham Arnold as a charismatic teacher and influence who drew large audiences to his lectures on Samuel Palmer, which he illustrated with slides and gramophone records. It was he rather than Morley who was 'contaminating'; generous, a manipulator, a man, says Morley, 'who pointed to the mountain tops'. He was also a man who loved clubs, secrets and secret societies. He and John formed a Beckenham Scarlatti Society. At the meetings they would drink Earl Grey tea together and savour the sonatas; the more so because they were so little known at that time.

Morley went on to the Royal Academy Schools, Arnold into a period of abstract, Bombergish painting which John did his best to get him out of. By then Graham Arnold had married Ann and they were living at Ashington in Sussex. John and Diana were desperately hard up but saw a cottage they liked in Suffolk. In those days you could still pick up such places for a song and they bought it. The distance between them didn't mean that they were cut off from Arnold-inspired outings; like those to Samuel Palmer's Shoreham by Lambretta to have exultant encounters with the *genius loci* that just might, they hoped, transfigure their own work one day, too.

David Inshaw had been a student at Beckenham too. Like Morley he had fallen under the spell of Graham Arnold, who kept in touch with his former pupils by means of long and ecstatically expressed letters. Together they formed in 1971 the Broadheath Brotherhood. Broadheath was the birthplace of Sir Edward Elgar, the composer who probably means most to the Ruralists. Like the later Ruralists, this Brotherhood too celebrated England; they read Richard Jefferies, Wordsworth and Milton. They immersed themselves in the spirit of Blake's Jerusalem and saw themselves as illuminated by his incandescent vision.

Would it not, Arnold asked Morley one evening in Epsom, be a good idea if they all got away from the *suburban* countryside around London to the *real* country? They could share things, pool resources, buy a big house somewhere, grow their own vegetables, help bring up each other's children and above all give up teaching and really get down to *painting*.

The Morleys thought not. They had only just bought the cottage in Suffolk. John admits to being territorial; he was relishing the pleasure of owning somewhere himself. He was suspicious of anything that smacked of a 'community' and saw discouraging examples in the past in such ventures as those founded by Eric Gill and CR Ashbee. John recalls that Graham was hurt by the rebuff. A little later he invited the Morleys to accompany himself and Ann on a long walk on the South Downs Way; it would be a great day out for the Broadheath Brotherhood. But John was in the middle of a ferociously crowded teaching schedule and at weekends all he really wanted to do was to get back to Suffolk. The Morleys declined.

A letter they received after that written in Graham Arnold's usual ecstatic prose mentioned, not entirely casually, that he had met Peter Blake and that they and David Inshaw had agreed to form a group which they proposed to call The Brotherhood of Ruralists. It would be devoted to the ideals of Elgar, Blake, Palmer, Wordsworth and so forth, and they were all very excited about it. The letter went on with many expressions of feeling for the children, the beauty of the countryside ('Oh England I adore you . . . God save the Queen!') and good wishes to them all.

Graham Arnold, St George in the Garden of King René, *1989, oil*

Graham Arnold, Dragon Hill, Uffington, *1985, oil*

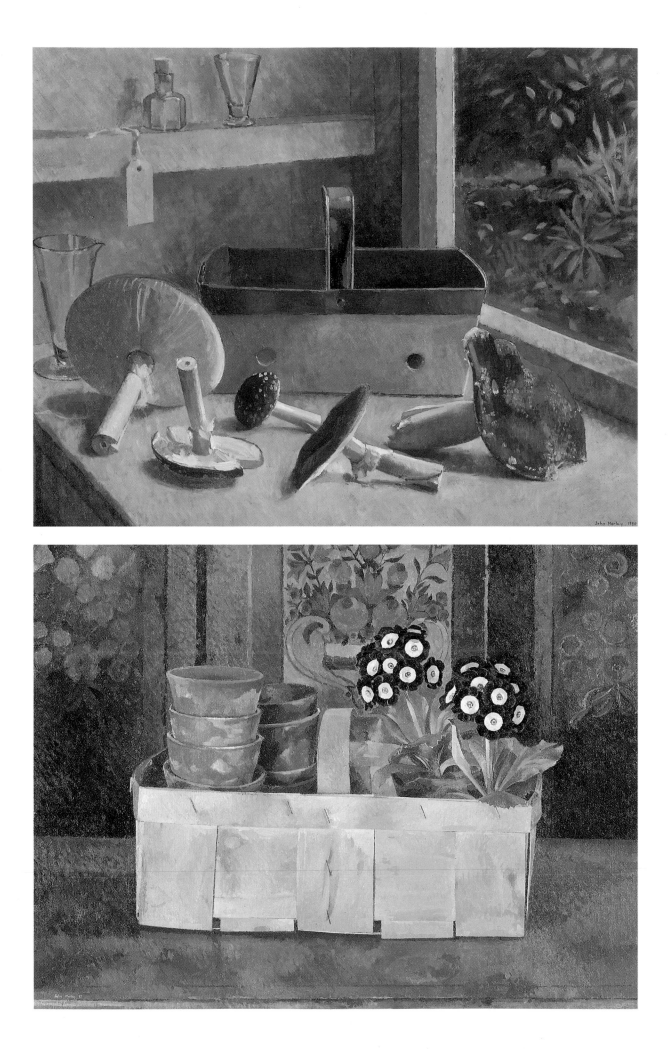

Both John and Diana Morley have become successful and highly valued artists and acknowledge that by not becoming Ruralists they escaped a lot of the controversy that the group attracted; furthermore their names shine the brighter for having made it alone. Nonetheless Diana still feels hurt by the exclusion and John acknowledges rather more than a twinge of regret at not being there when great things were afoot.

Peter Blake had no idea that anyone would feel at all left out of things. He saw it all as a spontaneous, spur of the moment thing that just happened, rather magically, in the warmth of companionship that had been generated among those present. Even the name was arrived at casually, without much enthusiasm. It sounded, he remembers, rather self-important; pretentious even. The echoes of the Pre-Raphaelite Brotherhood were a bit obvious. But no one could think of anything better and it cheered everyone up to discover that the dictionary definition of ruralist was 'one who moves to the country from the town'. That described them well enough; by now physically as well as spiritually. Peter Blake was living in a converted railway station in Wellow in Wiltshire with his American sculptor wife, Jann Haworth. He knew Graham Ovenden, who had moved from a semi in Hounslow to the picturesquely named Barley Splatt on the edge of Bodmin Moor. The Arnolds and David Inshaw were next door to each other, almost, in Devizes. David had bought a large house there where, he argued, there was plenty of room for him and the Arnolds. The Arnolds did live there for a bit but soon bought their own house too.

Though the missing manifesto wasn't taken too seriously, the Brotherhood was serious about the literary and musical sources of their inspiration. But they did not want to become over solemn about it all; they tempered the high thinking by planning a robust series of 'events'. There would be meetings four times a year, on the solstice. There would be an annual holiday when they and all the children would go off together to places like the Landmark Trust property in Coombe in Cornwall that they favoured. There, wholesome walks and huge communal meals punctuated the agreeable but arduous business of painting. There were seven of them and like the Secret Seven they scrambled over local sites, particularly those with a runic or mysterious atmosphere about them. Legend and folklore were sampled. Local heroes were investigated and celebrated; like the Reverend Hawker, an eccentric Victorian clergyman poet who had built himself an eerie on the cliffs from which he could espy not just the beauties of nature but also the attempts of his parishioners to lure passing vessels onto the foaming rocks below.

The satisfyingly mystic number of seven appealed to them and perhaps that is one reason why no new 'members' were ever admitted. The Brotherhood claimed that it was not exclusive; just that it was small enough to move fast and big enough to make a bit of a noise when it chose to do so. For all that, the apparent exclusivity rankled some and added to an impression they gave of slightly smug, rustic self-satisfaction.

When the John Read film was broadcast, the BBC Arts Department was divided into those who were spell bound by the apparent idyll and those who ground their teeth with irritation at their dereliction of the stern purposes of art.

Few Ruralists got more out of it at the time than David Inshaw. He relished the company, he treasured the opportunity it offered for constant reassessment of his work. His old teacher and mentor Graham Arnold was, so to speak, always on hand for encouragement and advice. Not that Inshaw was an unknown seeking recognition. He had already painted *The Badminton Game*, which was later to hang in the Tate Gallery. (It wasn't to hang there long; to Ruralist annoyance it now spends most of its

John Morley, Basket with Toadstools, *1991, oil, 35.5x45.7cm*

John Morley, Basket of Auriculas, *1985, oil, 35.5x45.7cm*

WILLIAM BLAKE AND SAMUEL PALMER

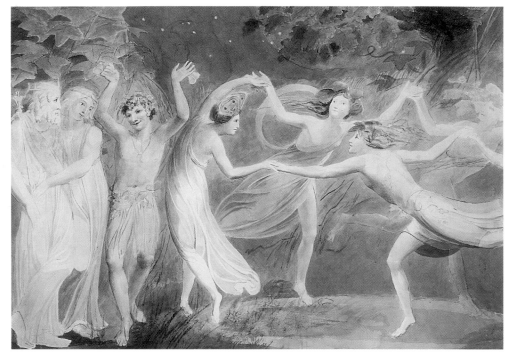

(above) William Blake, *Oberon: Titania and Puck with Fairies dancing*, c1785, watercolour, pen and ink on paper, 47.6x67.3cm; (above right) Samuel Palmer, *A Dream in the Apennine*, exh 1864, distemper and watercolour on paper, 66x101.6cm, from *William Blake and his followers*, Tate Gallery, London, 10 July to 3 November 1991, an exhibition of more than 150 watercolours, prints and drawings by William Blake from the permanent collection at the Tate, one of the leading centres for the study of his work.

Apprenticed to a copy-engraver as a boy – an experience that was to prove crucial to his development as a printmaker – William Blake (1757-1827) worked with the media of poetry, watercolour, drawing and

time in the vaults despite being reputedly the picture most sold in reproduction in the Tate shop.) His almost equally famous picture *The Cricket Match* had been bought by an art and cricket loving brewer.

Inshaw had come across the cricket pitch in Dorset. It is on the high hills on which Hardy's (Hardy as in 'kiss me, Hardy') Monument stands. It looks down on Portland and the sea in one direction and the iron-age fort of Maiden Castle on the other. It is a very Ruralist spot. Inshaw then was teaching at the Bristol School of Art and at weekends he and fellow artist Alf Stockham would leave their flat in Clifton and go off in Search of England. Their mini nosed towards Dorset as often as not, and Inshaw, a cricket fanatic, was transfixed by the English perfection of the ground. It only had a green, corrugated-iron pavilion, but Gloucestershire had been known to play there and the legendary Jessop, 'Croucher' Jessop, had once knocked balls out of the ground there.

A little further down the coast was Burton Bradstock. Inshaw and Stockham would sit in the pub there under the cliff and watch and listen to the fishermen who in those days still worked there. This Batsford book-like affection for England made Inshaw a natural and enthusiastic Ruralist before there

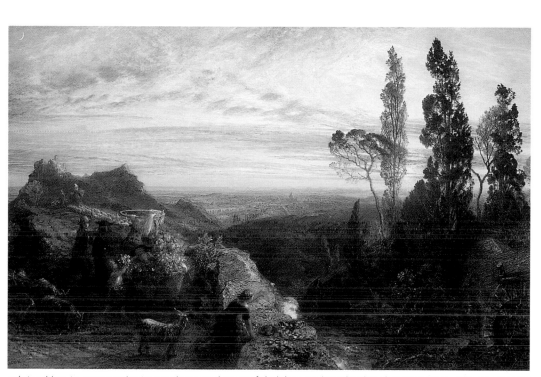

printmaking to communicate a unique and powerful vision, an imagination that sought to embody literary fantasy and metaphysics in works such as his illustrations to Dante's *Divine Comedy*. It was a vision, moreover, that was to act as an important inspiration for other artists, among them John Linnell (1792-1882), Edward Calvert (1799-1883), George Richmond (1809-1896) and Samuel Palmer (1805-1881) exhibited alongside the works of Blake at the Tate, who described Blake's 17 tiny woodcut illustrations to Thornton's *The Pastorals of Virgil . . . adapted for Schools* (published 1821) as 'models of the exquisitest pitch of intense poetry'.

was a Brotherhood at all. And even the most ecstatic and hallucinatory Ruralists like Graham Arnold share Inshaw's robust kind of response to the countryside, liking cricket and flower shows along with the Blake and the Elgar.

But the more exalted side of Arnold's vision had always excited Inshaw since he had been a student at Beckenham.

He shared the zest for Blake, Calvert, Palmer and Stanley Spencer; he was equally disgruntled by the state of British art and criticism and had been depressed by the uncommunicative *laisser-faire* attitude of his teachers at the Royal Academy Schools. When Inshaw moved out of Bristol he bought the large Georgian house in Devizes, Wiltshire which he invited the Arnolds to share with him.

For the moment the Broadheath Brotherhood satisfied their needs for an agreeably secret association of fellow spirits. But then Inshaw met Peter Blake at a dinner party. Blake invited Inshaw to exhibit at a show he was putting on for the Bath Festival. When he arrived in a furniture van to pick up the picture that Inshaw had nominated he met Graham Arnold, who was by then ensconced upstairs, and seeing one of his paintings immediately asked if he too would like to be in the Bath exhibition. It

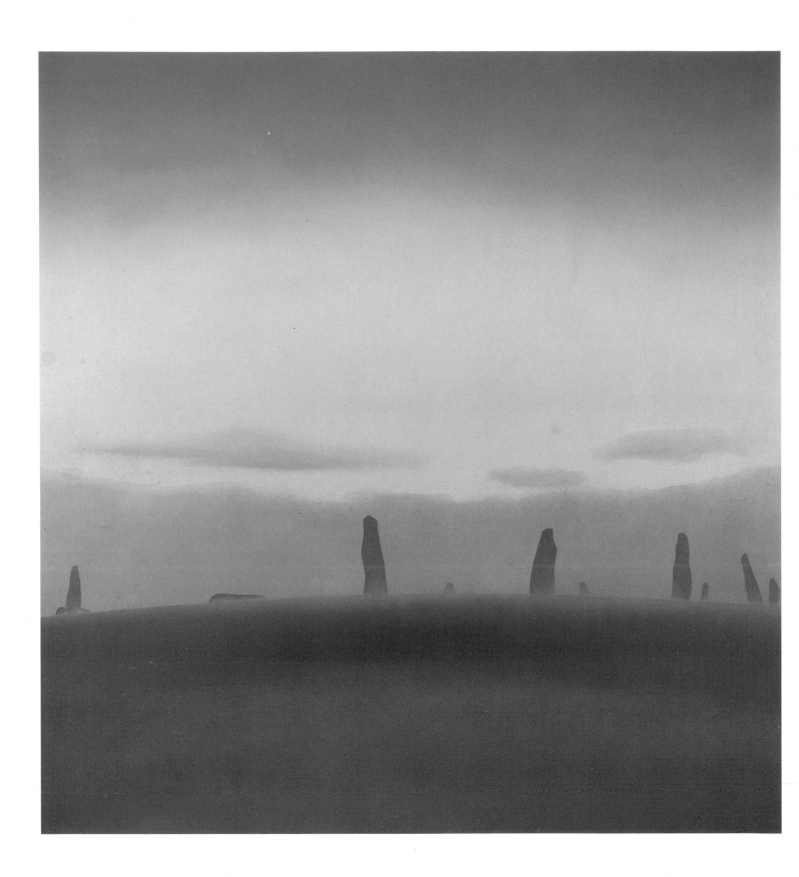

wasn't long before the Broadheath preoccupations were being shared with Blake, who was a sympathetic listener. He phoned his friend Graham Ovenden down in Cornwall about it all. Eventually, amid much cheerful eating and drinking, Blake put forward the idea of forming another Brotherhood. It was 21 March 1975 and it was Inshaw's birthday.

The Brotherhood would be *for* Figurative painting and *against* Minimalism and all its works. They would inspire each other and, by being something of a beacon in the darkness, others too. They would be dynamic, they would hold exhibitions up and down the country, away from the smart and corrosive world of London's West End. Artists tend to be lonely people; the Ruralists would always have the assurance of the interest, the affection and quite often the company of the other Brothers. As the Morleys were not there they were not Ruralists; nothing personal in that (Peter Blake didn't even know about them) but if you missed the inaugural meeting that was it, no one could be admitted thereafter.

Inshaw broke away from these heady events to arrive late at Trinity College, Cambridge where he had been appointed a sort of Artist Fellow in Residence. The lateness was not, Inshaw recollects, easily forgiven – particularly by Lady Butler, wife of RAB, who was then Master of Trinity. She was the college arbiter on matters of art and a certain chilliness in her dealings with Inshaw never quite melted. Then there was the formidable nature of Trinity itself. During those missing days at the beginning of term someone probably would have told him where the lavatories were and what time dinner was. As it was he was left to stumble about the enormous college as best he could. Dinner at High Table was not an occasion in which it was easy to relax from such anxieties. Nonetheless he had spacious rooms put at his disposal from which he asked that all but the most minimal amount of furniture be removed. Little was left but the brown lino. Wittgenstein, he was told gratifyingly, had made a similar request when he was a fellow.

The first term at Cambridge was sufficiently unappealing for Inshaw not to bother to go back there after he had returned home to Devizes for the vacation. After a couple of weeks of the new term had passed he received a phone call from Trinity. Wasn't he coming back? Oh please, he must. The last fellow like him had similarly failed to return and it didn't look very good, did it? He returned and the next five terms were much more enjoyable. Lady Butler apart, a *modus vivendi* was found, even with the rituals and terrors of the High Table. Graham Ovenden, whose enthusiasm for the pleasures of the table is legendary, came to dine amidst the venerable Fellows and Nobel Prize winners and was sufficiently unawed as to hang his jacket behind him on his chair the better to attack the Trinity cooking.

The college put on a Ruralist exhibition in the library, which was well received. Inshaw's *Badminton Players* was hung in the Lodge. Lord Butler, whose own collection of Impressionist paintings was famous, was appreciative and encouraging.

But a bigger show at The Royal Academy was more important. Peter Blake had been asked to hang Room 2 with his own choice of paintings and sculpture. He chose the occasion to reveal the existence of the Brotherhood. Room 2 looked, recalls Inshaw, very impressive. It showed that quite individual artists could retain their identity and still come together as a group to express similar concerns and ideas. In the corner of some of the paintings was the monogram BR to emphasise the common approach and hint at the existence of a mysterious club.

As Inshaw had expected, this gave the press a stick to beat them with. But there were lots more shows and if the price of putting one's head over the parapet had to be paid, there were compensations. Inshaw really feels that he developed as an artist in those days, that all his

Joseph Hewes, Standing Stones, *oil on board*

Brian Partridge, Moonlit Garden, *etching*

Brian Partridge, from Honey Comb, *etching*

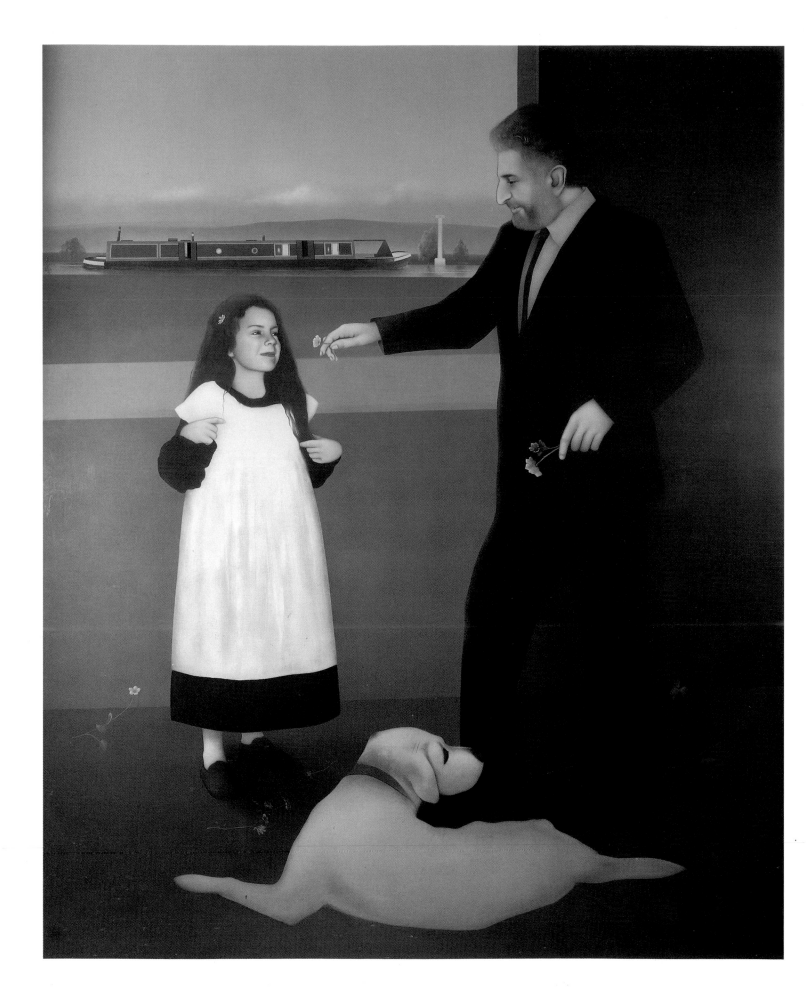

preoccupations came together for him. It focused what he felt he had to paint and provided the kind of critical structure around him that he craved. The picnics in Shoreham, the quarter-day meetings, the holidays, the general conviviality he remembers with the greatest affection. But like the Pre-Raphaelite Brotherhood, like the Society of Ancients, it had to end. And after about four years Inshaw thinks the Ruralists should have dissolved themselves.

As there were no formal articles of association for the Ruralists so there are no letters of resignation. But Inshaw moved away from them. The idyll in Devizes wasn't quite what it had been. The Arnolds had turned out to be oddly uncommunicative as neighbours and Inshaw felt the need for a wilder countryside to match the freer, more flexible style of painting that he was trying to achieve. He moved to Clyro, on the Welsh border, next to Hay-on-Wye. He doesn't exhibit in Ruralist shows any more although he is perfectly happy to do so if there is no 'Ruralist' label attached. He no longer has much communication with his old friend and mentor Graham Arnold. He lives now in an immaculately kept cottage with artist Shelagh Popham, a talented painter of garden and landscape.

David Inshaw is fearful of the dangers of falling into self-parody; he constantly feels the need for change. Through the window of the cottage you can see beyond the town to Hay Bluff, the subject of a series of paintings that is now under way, reflecting the progress towards the new style.

Graham and Ann Arnold feel no such qualms about the continuing value and vitality of the Brotherhood. Like David Inshaw they have moved into wilder country on the Welsh borders; in their case to an old farm house called Pentre. In 1986 Graham had been ill and a visit to the mysterious countryside between Ludlow and Clun in the south Shropshire Hills had done much to restore him. Devizes had begun to seem suburban and their house a bit small and the land where the hills are crossed by Offa's Dyke and melt into Wales are a Ruralist's dream. All around them are strangely shaped hills, rivers, and forests but the Arnolds seem content to paint the valley that surrounds their home. It is AE Housman Country, '. . . the land of lost content'.

Kingsley Amis wrote of Housman that 'he put into words what for most of us is no more than a vague glimmering, perhaps intensified at dusk, a fleeting suspicion that there is more in nature than can ever meet the eye, something within or beyond it, and no illustrator yet born could ever do justice to such mysteries.' This is to discount Palmer and the English entirely and in the evening as light fades on the hills and orchards, Pentre can seem more like Shoreham than Shoreham and one can believe that here, if anywhere, the Ruralist quest might be achieved.

Amis remarked that Housman ('my favourite poet') was scarcely a real countryman and was rarely to be seen striding along beside his ploughing team. For Housman the blue hills were indeed 'remembered'. The Arnolds however have thrown themselves into country life. They have taken on a big garden where they do Ruralist things like plant avenues and keep bees. They own a large hill behind the Pentre which they have planted with a thousand oak trees, most of which are doing well despite the droughts of the last two years. Two amiable donkeys live on the hill, keeping the grass down and providing dung for the bee-loud glade below. Ann is active in the Chapel Lawn WI, and as a climax to this embroilment with local affairs the Arnolds are at the heart of a sort of opera that is being put together about the area, based on written and oral accounts of local history and local life. When it is all over there will be an Arnold-decorated box containing scripts, music, maps and memorabilia that emerge from the event. Though the local community is, to say the least, small (population 33), the Arnolds have no doubts about its capacity to sustain such an experiment.

In front of the house rises a formidable-looking hill, much painted by Ann, which is crowned by an

Graham Ovenden, Family Portrait, *1987, oil*

Joseph Hewes, Angel in the Tomb, *1987, pen and watercolour*

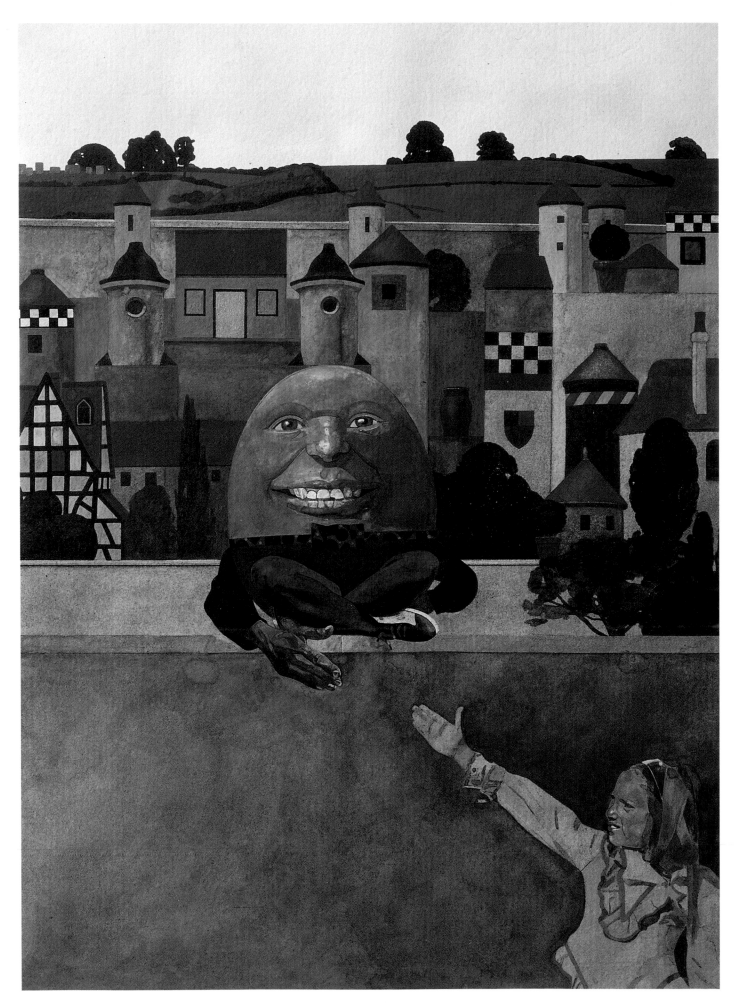

iron-age fort called Caer Caradoc. It is one of a system of such forts, markers of semi-legendary battles between Romans and Britons. The Welsh and the English engaged in centuries of warfare along the Marches here, which are resonant with melancholy associations that are very much to Ruralist taste. Ann Arnold's watercolours subtly catch the spirit of this haunted and haunting region. Both of the artists have responded to it with a new intensity. Ann often uses it to capture a medieval world; sparsely populated (few Ruralist paintings are crowded), enchanted, where unicorns and magic children are all that one is likely to encounter in a landscape that has been transformed into a paradise garden.

Graham's pictures also transform the surrounding landscape and even more evoke the splendours of a fabulous, archaic past. Arthurian helms, tents that look as if they have been erected for a tournament or joust; twining ribbons and bright flowers bestrew the scene under clear, dream-like skies. For some this is all rather literal; they would prefer the evocation to be more understated, but Arnold has always liked filling the canvas with assemblages of things; the forms of collage keep reasserting themselves.

South Shropshire is very far from being an artistic wilderness. In nearby Ludlow the enterprising Silk Top Hat Gallery runs a programme of exhibitions and events that quite often feature Ruralist work. The Arnolds have been instrumental in mounting shows in Machynelleth, the ancient capital of Wales and at Bleddfa, just over the Border in what used to be Radnorshire, there's an old school that has been converted into a small gallery. The Ruralists and their friends like the Morleys and John Partridge put on a show there every summer. There's always a theme with sympathetically Ruralist associations: 'Alice', 'The Secret Garden', 'The Family'. The exhibitions draw decent enough crowds even if sales to the local hill farmers are not frequent. (The homeliness of the surroundings doesn't mean that Godfrey Pilkington of the Piccadilly Gallery isn't keeping a sharp eye on things; you can't get a cheap Peter Blake at Bleddfa.) The show usually goes off on the road to Plymouth, Oxford and finally Cork Street. These travelling exhibitions take more time than the Arnolds can easily find and they are much assisted by Michael Fraser, an old crony who left the Tate Gallery to risk a precarious free-lance life in Ludlow with his wife Adele.

Graham Arnold is a tall, imposing man whose long and sometimes rather disconcerting silences can give way to quite long monologues. These range from anecdotes of surreal incidents during his army career to impassioned observations about art, the country or the iniquities of the South Shropshire District Planning Committee and their philistine and ill-conceived policy on barn conversions.

His enthusiasm for music goes beyond having Radio 3 on in the background while he paints. His knowledge, as well as his brilliance as a painter, is much admired by his fellow Ruralists. He is currently illustrating a book of the *Epic of Gilgamesh*. 'Do you know,' enquired a visitor to Pentre, 'that Bohuslav Martinu wrote a suite on the same theme?' 'Yes,' said Arnold icily, 'I do.' Again, in the matter of Gilgamesh the publisher asked the erudite Arnold to change his ideas about how the ark looked and generally to make quite a number of changes. 'I am not an illustrator, I am an artist. If I had wanted to be an illustrator that is what I would have been.' The number of illustrations was sharply cut.

To me he seems the most ruralist of the Ruralists, a Ruralist's Ruralist. I once walked over the hills near Pentre with him and Ann. Progress was not rapid as Graham would make frequent stops. These were not pauses to take breath so much as to inhale rapturously the beauty of the world around him. 'My painting has always been an attempt to express my world view, my own loves and interests into a personal Myth,' he once wrote. 'I want to make a *Unity* of all the facets of being alive, of feeling

Peter Blake, and to show you I'm not proud, you may shake hands with me!, *1970-71, watercolour*

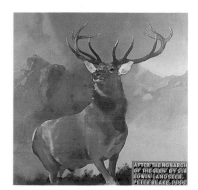

Peter Blake, Monarch of the Glen, *1965-68, Cryla on canvas, 121.9x121.9cm*

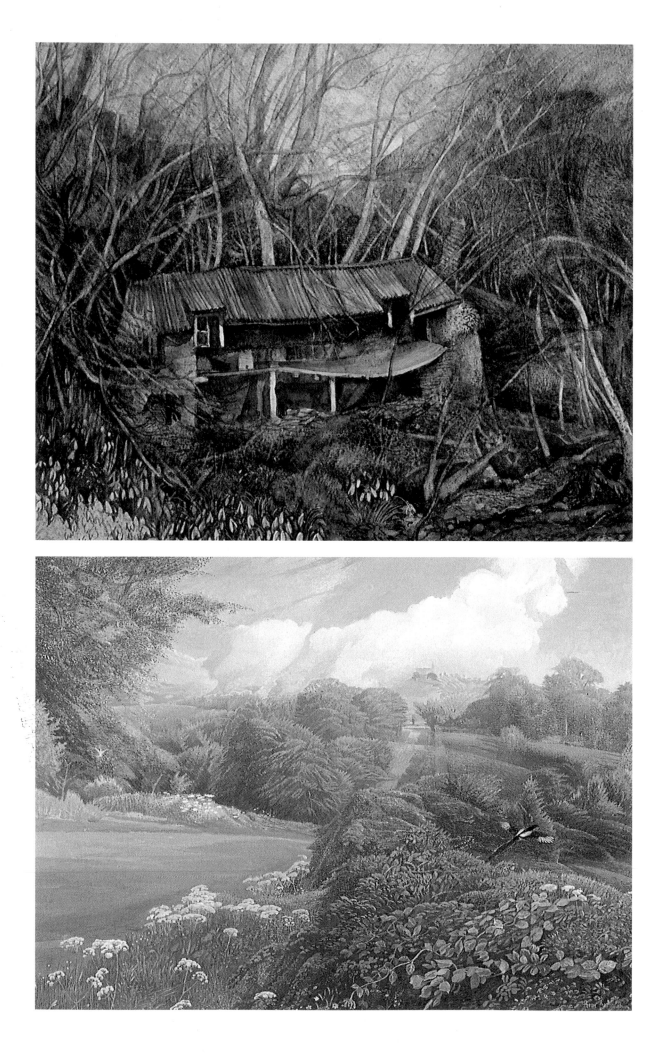

powerful emotions, of loving and this includes the beauty of the miracle of reality and all these things form the substance of my myth. I am seeking through painting a poetical interpretation of all those things which move me and over the years have become part of me and which I value above all things.

Graham Arnold reminds me of the gaunt shepherds who brood protectively over their flocks in those Samuel Palmer pictures. His is the still authority that helps to keep the Brotherhood together despite the distances between them and the wear and tear that the years have inflicted on them. It is not perhaps too fanciful to see Graham Ovenden as the sheep dog; bounding up and down from Cornwall, patrolling the Welsh Marches to make sure that things get done, chivvying up the slower members of the Brotherhood for transparencies and copy for Ruralist publications, keeping an eye on the London end of things, and generally making sure that the ideals and sense of mission of the original Ruralist vision are kept intact and the brethren in good heart. He's more combative than any of the other Ruralists; more inclined to polemic and, as things have in many ways gone the Ruralist way in the last few years, more inclined to take on the opposition. The opposition tends not to be just those whose deadly creed of modernism Ovenden believes to be on its last legs anyway, but all those who are faint-hearted about – or hostile to – the divine imperatives of art. If Graham Arnold points the way to the mountain tops, Graham Ovenden spends a lot of time actually in them admiring the view; the greatest music, the most Olympian critical writings, the most enduring Old Master painters are the diet on which his mind and conversation feed.

To meet Graham Ovenden, however, is not to feel that one is encountering Ruskin. He has the disarming mien of the English eccentric; he sports a WG Grace beard, steel-rimmed spectacles and usually wears an English eccentric's hat (his favourite being one which he wears indoors and was given to him by Sir John Betjeman). This is all rather deceptive. The passion with which he holds his views on art and the scorn in which he holds the foe are soon apparent. He has, famously, been constructing his own house, Barley Splatt, for several years. It is the only important exercise in Neo-Gothic that is being built in the country at the moment and it enshrines many of his enthusiasms. Perhaps surprisingly, because Ovenden comes on rather like William Morris, it is not in Arts and Crafts Gothic but more in the style of the High Victorians who have always been Ovenden's especial heroes, particularly William Burges to whose Castel Coch the emerging Barley Splatt owes some of its inspiration. But the choice of materials, the highly personal ornament and decoration, the strangeness of the over-all effect make the building far more Ovenden than any of his influences. Architectural writers make the journey down to the edge of Bodmin Moor to gaze awe-struck at work in progress. It will be many years before Barley Splatt is finished and it has already taken many years to reach the stage it has. This is not least because designer and masterbuilder Ovenden cuts and lays the granite blocks himself as well as executing as well as designing – with some architectural help – every stage of the building process.

Beside the front door of Barley Splatt the branches of an ancient oak tree writhe and twist anthropomorphically. To the side of that there is a poetically ivy-mantled ruin. It looks like a lonely anchorite's cell but was in fact a dilapidated outside lavatory. There is a huge lawn. In the middle the Ovendens have created a large pool which under leaden skies can look like some haunted mere from *Morte d'Arthur*. Around lie nearly 30 acres of pure ruralism; a gurgling river, woods, overgrown meadows and a glimpse of the moors above. This is Ur-Ruralist country; the scene of many a convivial get-together, the dripping woodlands the location for many famous artistic endeavours like the series of 'Ophelias', once a Ruralist theme.

Ann Arnold, The Ruined Cottage, *oil*

Ann Arnold, Introduction and Allegro, *oil*

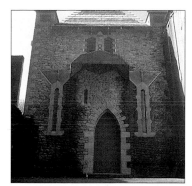

Graham Ovenden, Barley Splatt, near Bodmin, entrance and detail on east facade, begun 1973

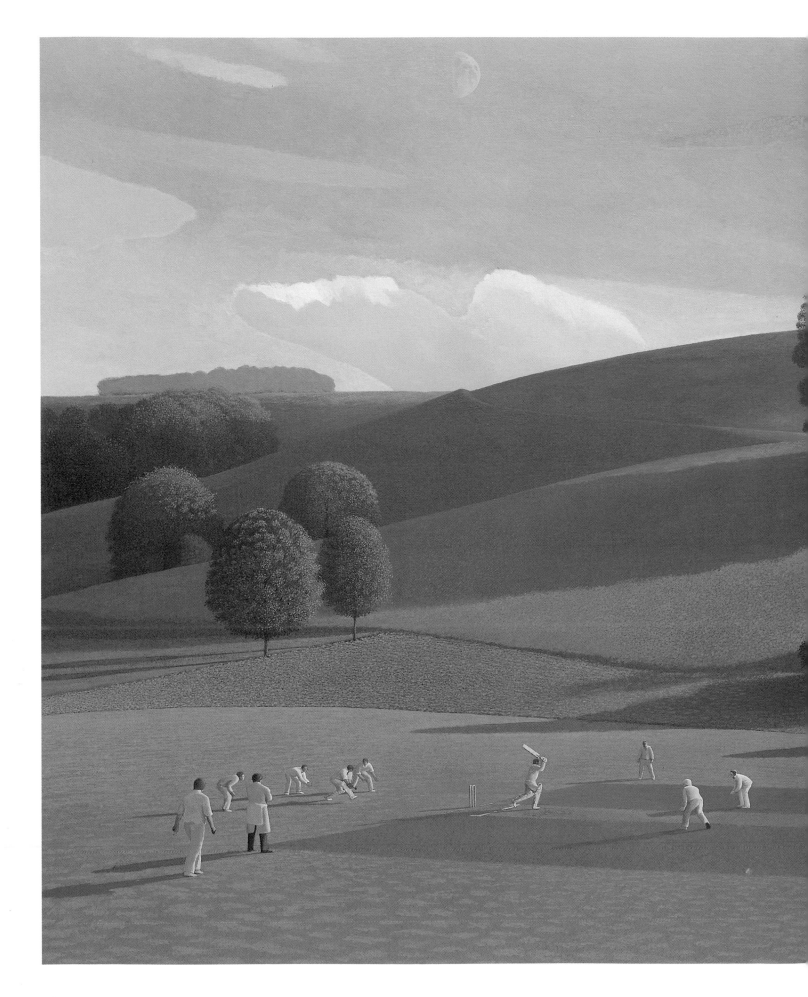

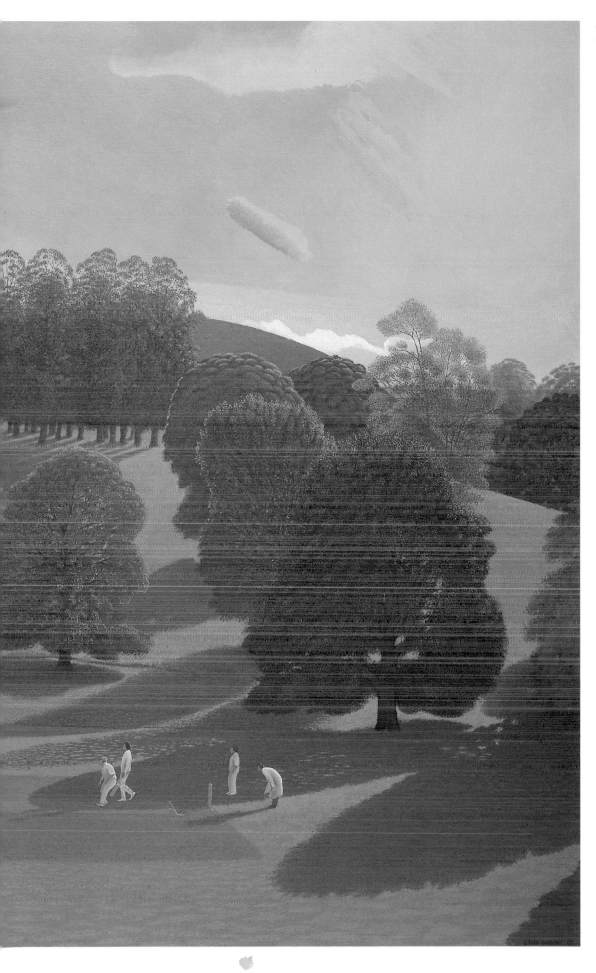

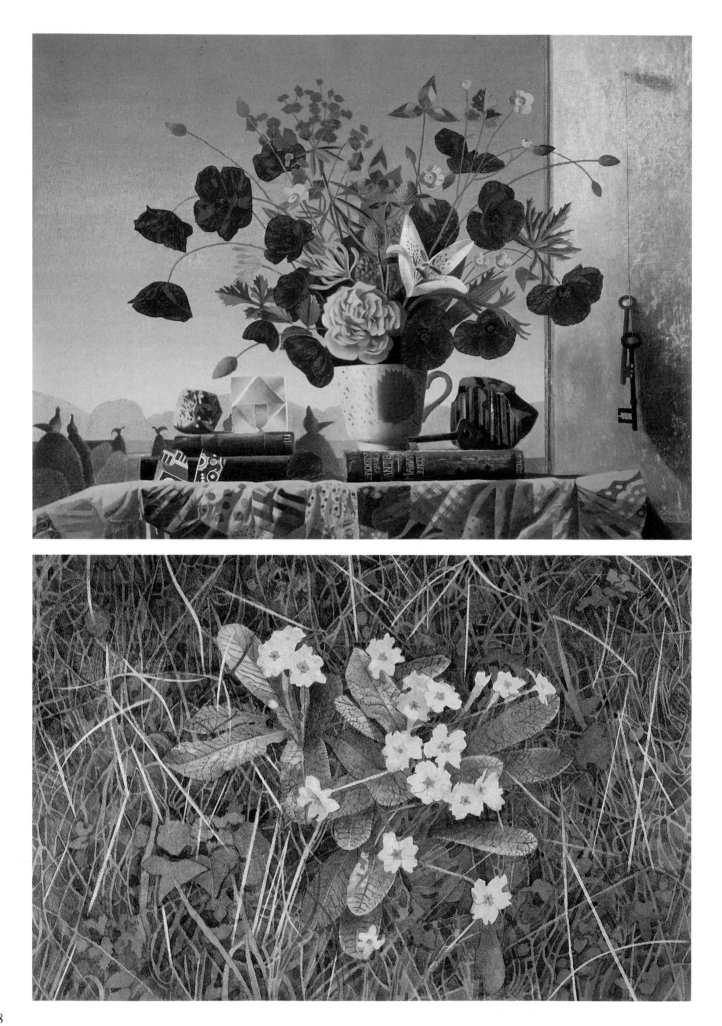

The interior, which might seem to have caught rather too well the atmosphere of High Victorian gloom which Ovenden favours, is lightened and made more human by piles of washing that have been abandoned on the floor by visiting nieces and nephews.

The stairs and the hall upstairs as well as the kitchen are finished. Downstairs the floors are inset with ecclesiastical-looking tiles. Upstairs heavily patterned wall paper and authentically woven carpet provide the frame-work for Graham's collection of elaborately carved furniture. There are pieces by Seddon, Street, Gilbert Scott, Webb. A particular treasure is a large carved side-board and mirror by Pugin. There used to be more. The not infrequent winds of economic adversity have obliged Ovenden to sell off some of his greatest loves. But nonetheless the effect is impressive and houses magisterially Graham's fine collection of books and photographs. As a collector he is an eclectic. He is one of the country's greatest experts on Victorian photography and his collection is famous. He has recently become fascinated by *Titanic* memorabilia and his pleasure was palpable when he returned triumphantly from a London sale room with a yellowing photograph of Captain Smith and his fellow officers lined up on the bridge of the doomed ship.

Ovenden's enthusiasms spill into the studio. A curiously square-shaped piano stands in a corner on which the great polymath requires little persuasion to give a stirring performance of the *Apassionata* sonata or a Schubert *Impromptu*. Most of the Ruralists seem to like music while they work. Ovenden has a passion for acoustically-recorded arias sung by long-dead divas. These he likes to play in their antique shellac on a wind-up gramophone from which the tones of Tettrazini and Melba float with eerie, scratchy authenticity. There are many very old and authoritative recordings of Sir Edward Elgar conducting his own work; the cello concerto played on gut strings rather than metal and the violin concerto played by Albert Sammons as well as by the young Menuhin.

Ovenden was a student at the Royal College of Music before he became an art student. As a child he was taught by Albert Ketelby, the composer of *In a Persian Market Place* and *In a Monastery Garden*. These had been so successful that Ketelby had retired to the Isle of Wight, and thither the young Graham would travel by ferry across the Solent for lessons. But it was about then that he also had one of his first encounters with English Philistinism. He was threatened with expulsion from school when he was 'caught' playing Bach (Bach, mind you!) on an old piano that stood outside the staff-room where the teachers were smoking and drinking coffee during break. It still rankles. He claims to have been an unspectacular student at Itchen Grammar School but by the age of twelve he was already reasonably well up on Pugin and the great Victorian designers. When he was a student he bought a Burges sideboard cheaply long before the revival of interest in Burges. He learnt, he says, a lot from Lord David Cecil and Sir John Betjeman.

He is eloquent on the subject of modernism, although his disapproval is not always voiced in the tones of a Kenneth Clark: 'It's fucking difficult to paint figuratively. Have you ever seen the early, figurative works of Mondrian? Or Jackson Pollock? Well, they're terrible. They couldn't do it.' Neither is he keen on the wilder, most narcissistic shores of contemporary British art. 'I don't believe in the personality cult and the idea of the autonomy of the artistic genius is much over-done. More profound gestures have come out of my arsehole . . . Look at Chartres Cathedral and the sculpture there. We don't know who did them but they rank with anything that has ever been created, including ancient Greece. They are the work of someone who acknowledged someone or something greater than himself. Paradoxically it is modesty that leads to greatness. Look at Rembrandt's late paintings; a supreme expression of art. They're painted by someone who knows how great he is – but is humble.

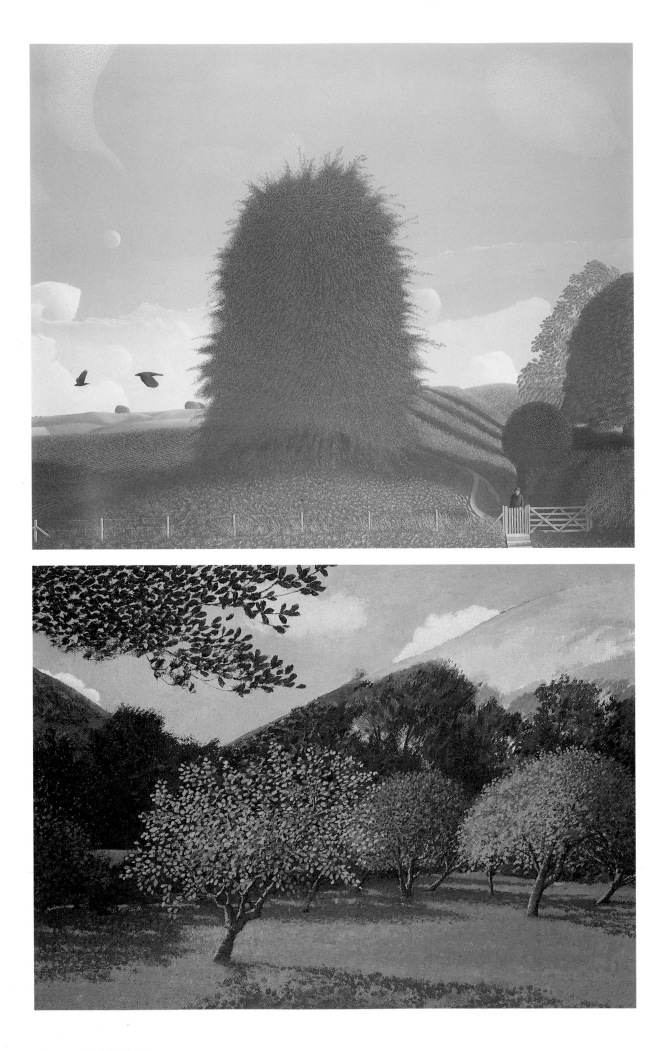

Like Shakespeare. Like Milton. Like Stanley Spencer. For the most part artists are master craftsmen.'

The whole history of abstraction needs to be re-written, he thinks. And one thing is certain in his mind: figurative and easel painting became unfashionable at about the same time that ornament and pattern became unfashionable in architecture. 'But buildings need ornament. All of the great architecture of the past had ornament as a matter of course. Islamic architecture does today. It's not just a question of decoration; it's symbolic, it's fundamental. It's the assertion of humanity in a building. The Prince of Wales did a magnificent job for British architecture; especially with the TV film by alerting the public to the absurdities of what was going on. Not that the public didn't know already. But he made it legitimate to say so. If only he'd direct his fire at British art and make a film about that. Oddly enough, modern abstract art works well enough as decor; it's when it gives itself airs and pretends to be profound that it shows its limitations. It doesn't convince. It can't do it.'

Helpfully, Ovenden opens one of his venerable books. It is an 17th-century volume by one Robert Fludde and it is an attempt, much prized at the time, to put the ideas of Neo-Platonism into diagrammatic form. The pages are full of squiggles and lines that look, indeed, very abstract. One diagram, which is meant to represent the depth of the cosmos, is an entirely black square. Malevich would have approved. This is abstraction with a purpose but Graham Ovenden has never been tempted to do it, even though Graham Arnold and David Inshaw were. Ovenden is glad that they grew out of it and that he had a hand in their redemption from error. He would rather see the cosmos through the eyes of Blake than as a black abstraction and no, he doesn't think that he and the other Ruralists were unworthy followers of that tradition.

There was for Ovenden nothing light-hearted about the foundation of the Brotherhood. It was desperately serious then and it still is. The break-up was a tragedy with Peter Blake going back to Chiswick after the end of his marriage with Jann Haworth and David Inshaw taking himself off to Wales after apparently falling out in some mysterious way with the Arnolds. British art needed a rallying point of the sort that they provided and it still does. Anyway the Ruralists are still very much in business. You can't exactly *resign* from the Brotherhood any more than you can get chucked out of it because there are no rules you can have broken: 'It never ended because it never began. And anyway Inshaw never could take the flak.'

A walk amidst the rain-soaked meadows restores his equilibrium. 'I believe in the sanctity of art if not of God. Ruralism gave Graham Arnold the confidence to abandon modernism and stimulated David Inshaw's change to a looser, more painterly, rougher approach. There wasn't ever any need to become self-conscious about one's work and they had all learnt from Peter Blake not to be afraid of *precision*. Peter can paint the sharpest line in Western art today.' In comparison his own paintings, he says, are just pretty pictures of the landscape. But they are nonetheless 'works of ecstasy, rejoicing in the presence of nature, celebrations of a glorious relationship. The Ruralists, he says, are greedy, they want to provide a feast. No wonder the critics are irritated. And it's not easy. Look at early Rembrandt, early Degas. They weren't that great then. They had to work at it; they sweated their way through. Artists at their best have this spiritual thing happening, they pare away the unessentials and communicate their deepest, internal responses to the viewer.

And little girls? Much has been made of the Ruralist preoccupation with pre-pubescent girls; from Peter Blake's fairies to Graham Arnold's ravishing children to Ovenden's own Lolitas and nymphets. These are far from being portraits of innocence; indeed these children look out at us with disconcertingly knowing, equivocal eyes. How do they fit into the Ruralist vision? Ovenden is

David Inshaw, Bonjour Mr Stockham, *1975, oil, 152.4x182.9cm*

David Inshaw, Coombe Valley, Cornwall, *1977, oil, 21.6x29.2cm*

OVERLEAF: Graham Ovenden, Old Mine Workings, Welsh Borders, *1989, oil, 121.9x203.2cm*

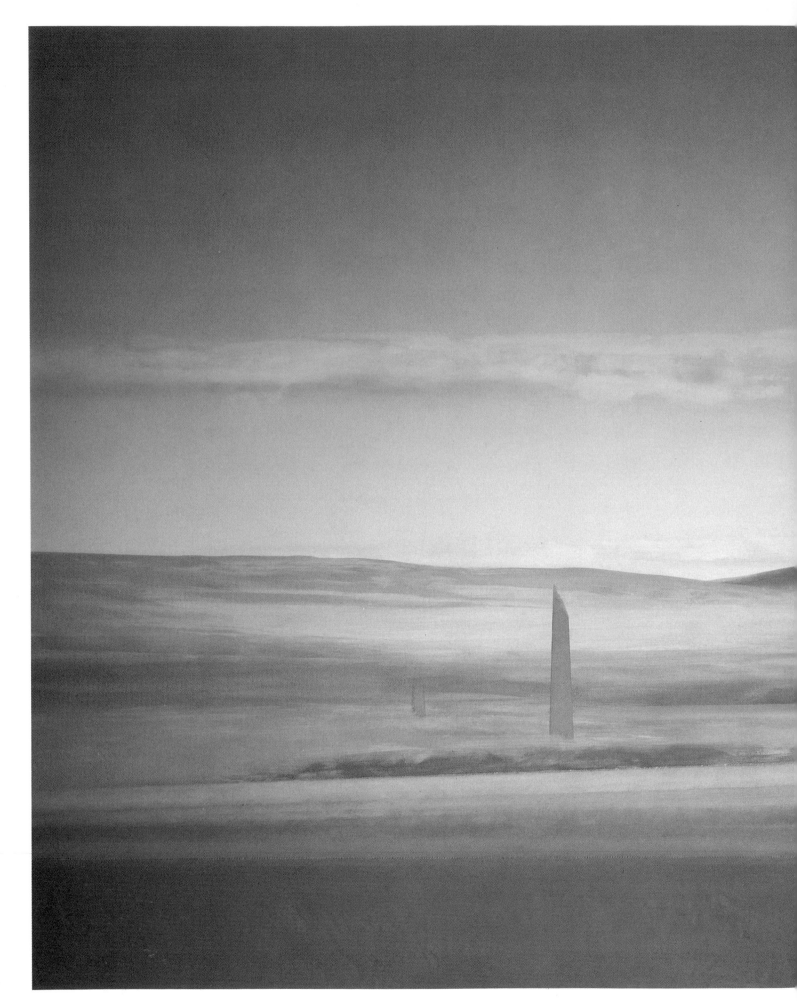

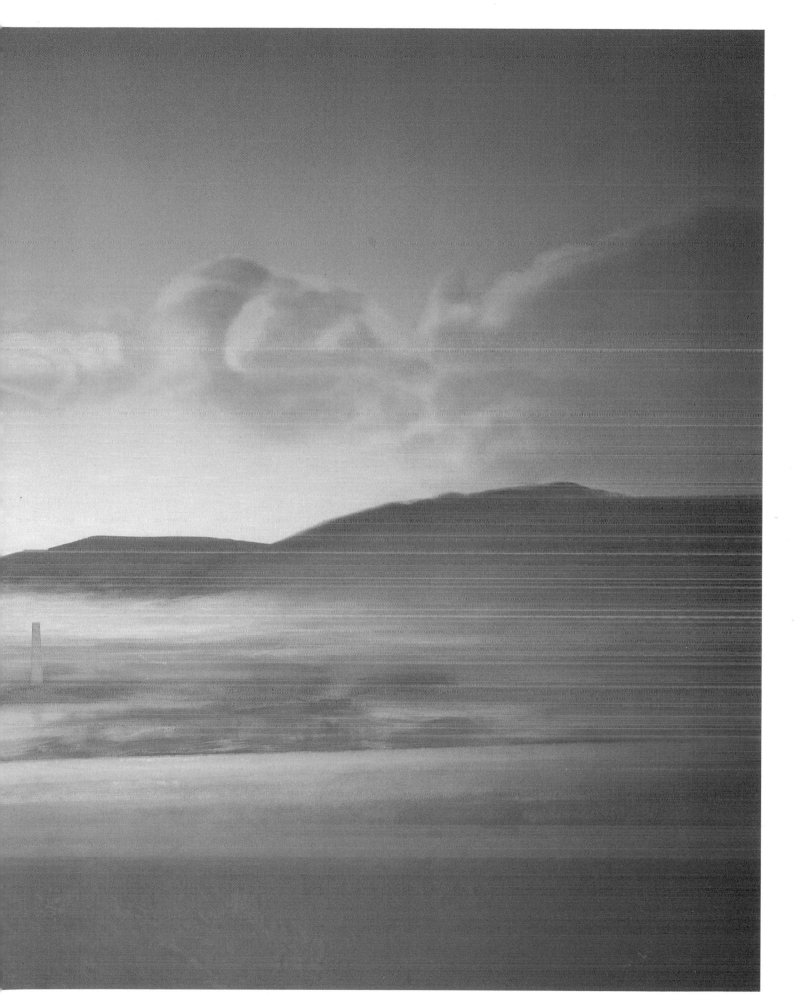

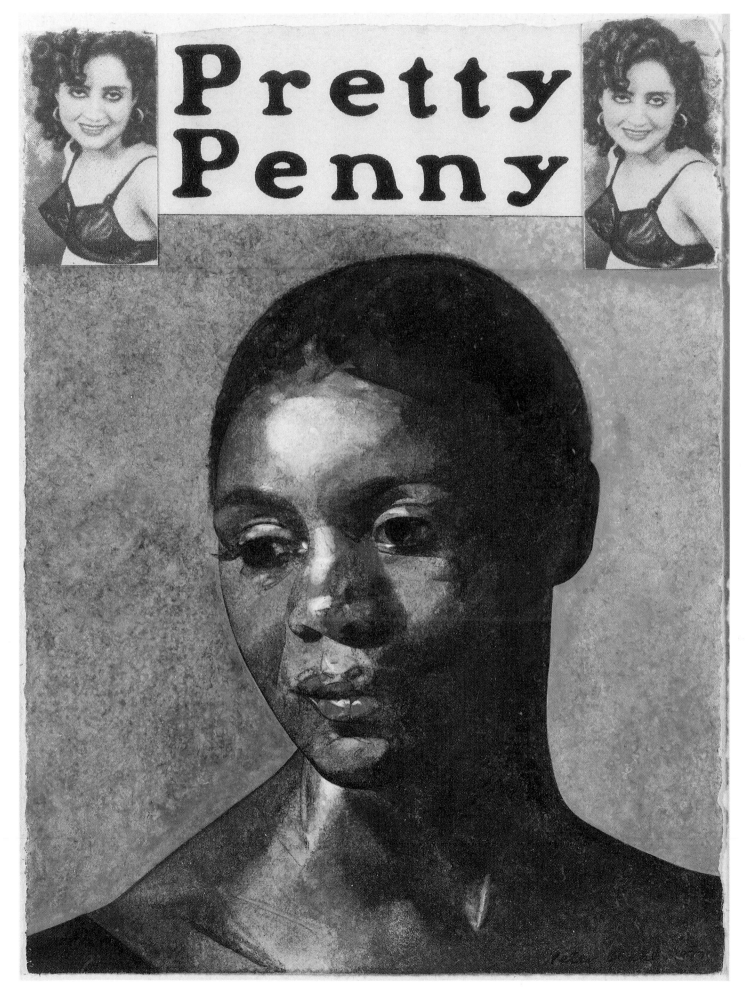

Pretty Penny

exasperated that the question is even asked. The fact that it so frequently is reveals more, he believes, about the age than it does about him.

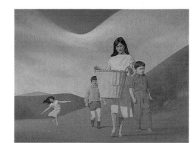

I have a sense of ecstasy and joy when I see them and I have to paint them. I don't, I hasten to say, want to do any more than paint them. Or I want to photograph them. Photography is the greatest medium for catching the feeling of mortality that surrounds them; look at Lewis Carroll. And yes, they do fit into Ruralism. They're very much to do with nature, with spring; they're virgins. However much people disapprove I have to do it. Even if they threatened me with prison I'd have to do it and I'd go on painting them even if I was in prison. It's an artist's duty to do that. Would Ovenden almost welcome an Oscar Wilde-type trial in which he could declaim the principles of his art to an astonished world? He was once arraigned at the Old Bailey over a matter of some photographs which for a joke he had put into an exhibition at the National Portrait Gallery. These purported to be by a mythical Victorian photographer called Hetling. The 'Hetlings' eventually turned up for sale sometime after the show and harsh things were said about Ovenden's role in it all by an enraged buyer. The trial lasted some days and the Ruralists used to go into court to watch the proceedings, listen to John Mortimer who was counsel for the defence, and generally support the accused, who seemed to enjoy the proceedings and the opportunity they provided for drama. The judge's summing up however was lethal and the possibility that a prison sentence awaited a senior Ruralist had a sobering effect on them all. Ovenden, Inshaw remembers, was ashen and uncharacter-istically quiet as they enjoyed a last pub lunch together before the jury gave its verdict. As it happened, Ovenden was not to be the first Ruralist martyr; he was found not guilty and the case became an episode in Ruralist folklore.

'We're the avant-garde now,' Ovenden says. 'We've inherited the banner of opposition to the prejudice and ignorance of the establishment. We are the successors of Cézanne. People are desperate for good art nowadays and although I don't always want to be going on about the iniquities of the modernists I certainly don't want to be numbered with the bad guys. There are probably about 30 people in this country who hold down important jobs in the arts; in the museums and art galleries, in the art schools, and in the media. They do far more damage to art than any of the supposedly philistine politicians.'

'Graham Ovenden is the prime force in Ruralist polemic,' says Peter Blake. And a bit of polemic was certainly one of the things that the Brotherhood was founded to provide. Even as famous an artist as Peter Blake felt isolated, even lonely, as a figurative painter back in the early 60s and 70s. 'It all started as something convivial and fun but it soon, without becoming too solemn about it all, became more serious,' he recalls. If there was a manifesto, it was for sentimentality. It was for Love and Friendship; not qualities rampant in the art world in those days. And, he believes, it changed art a bit too.

Peter Blake left the countryside after his marriage with Jann Haworth broke up. He now lives within ear-shot of the buses that slowly grind their way up and down Chiswick High Road and so *de facto* he can hardly be accounted a ruralist in the dictionary sense of one who leaves the town for the country. Nor is he the obverse, an urbanist exactly. The subjects he chooses to paint are very much the same as he painted during the years at Wellow, and indeed he never got rid of Wellow after he left Wiltshire. Now it's being opened up again for more sorties to the countryside.

The themes may not have changed but many of the canvases have. He sometimes takes years over a single picture; his Titania is being reworked for the umpteenth time before she re-emerges at Waddington's. 'I never wanted to paint pure landscapes anyway. If I wanted to paint a river and a

PETER BLAKE AND POP ART

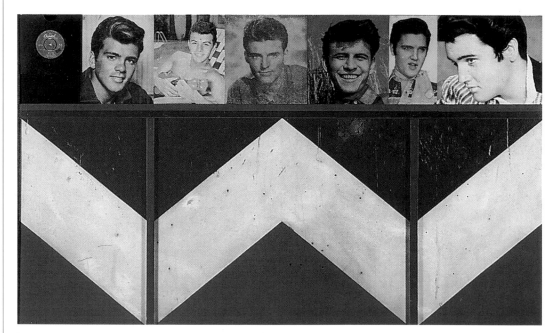

(above) Peter Blake, *Got a Girl*, 1960-61, enamel, photo collage and record, 94x154.9x4.2cm; (above right, left to right) *A Museum for Myself*, 1982, collage, 115.3x86cm; *Girlie Door*, 1959, collage and objects on hardboard, 121.9x59.1cm.

Blake was rare among Pop artists in seeking to reintegrate his art into the popular culture from which it sprang, thanks primarily to the fact that he continued to work occasionally as a graphic designer and to think such illustration a form of expression as respectable and worthy as painting or sculpture. He made his greatest stride into mass acceptance in 1967 with the cover design for the Beatles' *Sergeant Pepper* album, and in the same year he produced a multiple printed on tin, *Babe Rainbow*, which was produced in vast quantities and initially sold for as little as £1 on street markets.

Collage-based pictures and assemblages from popular ephemera and other found materials were still produced by Blake on an occasional basis, notably in a series of Souvenirs intended as gifts for other

bridge I'd probably want to put a few fairies in.' Nonetheless it is important that the figures like Alice are in a landscape. 'I used to read Millais' Journals; I loved the idea of painting Ophelia in the open air. I liked us going on holidays together, going to the pub, talking about art, drawing out of doors together.' One of his latest pictures is called rather archly *I May Not Be A Ruralist Anymore But I Saw A Fairy In My Chiswick Garden*. It doesn't look as much like a fairy as his famous series of fairies which featured in his exhibition at the Tate and which infuriated Peter Fuller and other critics so much. He claims not to be much concerned by that sort of thing. 'The art critics were Marxists, most of them and my fairies are a darned sight more realistic than their revolution,' he is reported as having said. It's Graham Ovenden who gets angry and upset, dashing off cross philippics and tortuous, insulting acrostics about the tormentors of his friends. Blake says:

I am a tree, so to speak. The trunk is straight and fairly traditional. Where my art has left to go on different excursions there are branches like Pop, wood engraving, and Ruralism. They all may look unalike but they come off the same stem. What I am working at now is in direct line with what preoccupied me 25 years ago; the same fantasies. I've always wanted to explore the limits of

artists, but from the late 1960s he returned essentially to the 'figurative realism' that he still regarded as the core of his work. This was particularly the case with the pictures of fairies and literary subjects with a strong Victorian flavour that he produced after 1969, when he settled with his wife in the countryside at Wellow, near Bath, until their separation ten years later. After this period as a member of the self-styled Brotherhood of Ruralists, an association of artists founded in 1975, he moved back to London and began using once again some of the urban themes of his earlier work. He made a conscious and witty return to the images and methods of his classic Pop works for an exhibition held in Tokyo in 1988, 'Déjà vu', which he conceived as a post-modernist statement about his own work, producing both new variations on particular types and second versions of specific works, as in *The Second Real Target, 25 Years Later* (1988). With these pictures he demonstrated the continuing vitality of his brand of Pop while bringing his own history as a Pop artist full circle.

Marco Livingstone

humanity: I've always been more interested in disability than perfection. So strippers, wrestlers, fairies are all . . . unusual. I used to collect books and I liked ones illustrated by Arthur Rackham. I was fascinated by Richard Dadd. I see Titania as being about half the size of a human being and her attendants being half the size of Titania. She's Shakespeare's Queen of the Fairies but she might have lived by the side of the river at Wellow. She's naked so how do I adorn her? I've imagined she'd have leaves for boots and she'd decorate her nipples with grass and I've twined daisies into her pubic hair . . . She's quite sexual.

A cousin then of Graham Ovenden's Lolitas? 'She is very much a girl-woman with a woman's head on a girl's body,' he agrees.

Leslie Waddington was always against Inshaw or Blake surrendering their identity to a group like the Ruralists. Godfrey Pilkington on the other hand has always thought that the Ruralist label was anything but bad for business; if it drew some unfavourable flak it also attracted a lot of attention to their exhibitions – even after the first flush of Ruralism had died down. Blake thinks it was good for Inshaw to push off when he did and it was necessary for Blake to move on after the collapse of his marriage to

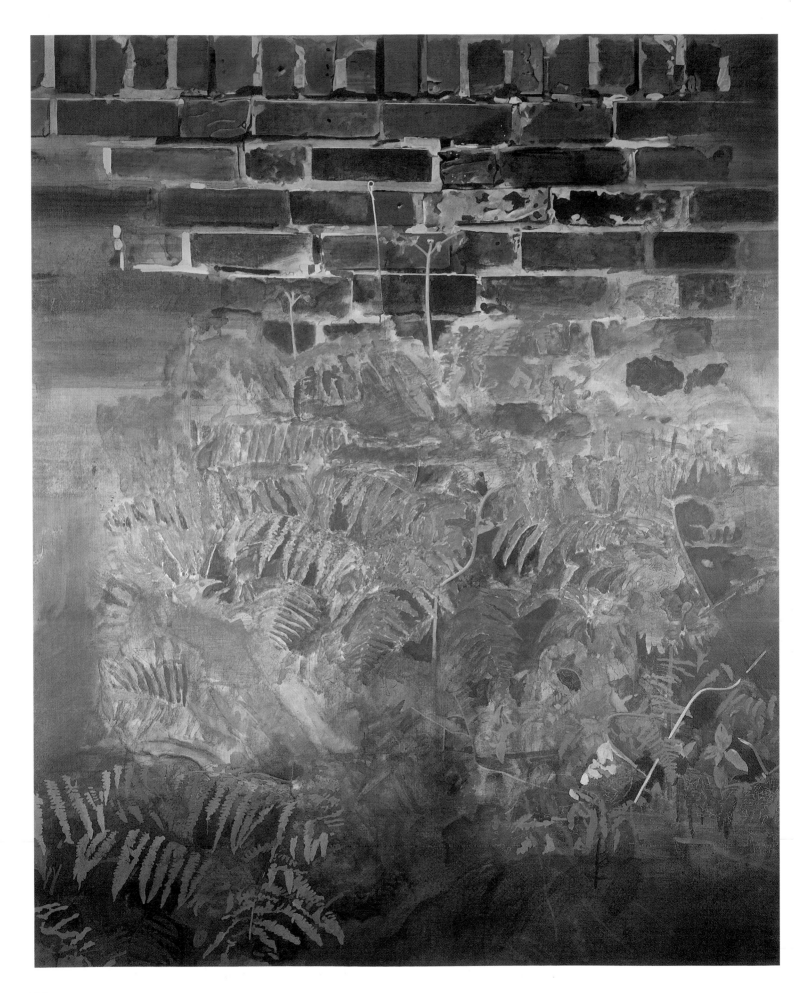

38

Jann Haworth.

'Everything ends. It's like leaving home to do national service or something; you move on – and David's career needed it.' Blake is aware that his departure as the most famous and glamorous Ruralist might have finished the Brotherhood off and is relieved that it didn't.

In fact Ruralism has had a long and unexpectedly successful after-life. He acknowledges that the Ovendens and the Arnolds saw to that. Peter Blake still contributes to the exhibitions, which he thinks seem to go better and better. In some ways he thinks it's all more effective now, in its apparent decline, than in the heady days of its inception. Now the first frenzy is over they have all settled down to do better and better work; particularly the wives Ann and Annie.

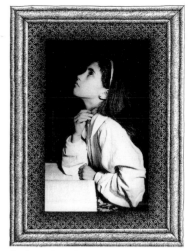

Peter Blake, I May Not Be A Ruralist Anymore But I Saw A Fairy At The Bottom Of My Garden This Morning, work in progress, oil

Graham Ovenden and Brian Partridge, illustration for Alice, 1985

Blake shares the admiration each of the Ruralists has for the others' work. It comes in part from a respect for the sheer skill with which they paint. It makes them suspicious of inflated reputations based not on any discernible skill but on fashion and dogma. They are very sceptical about over-rated schools of painting – however famous – which helped take art away from its traditions. Peter Blake wrote a disparaging article in *The Independent* about an exhibition of Monet's series paintings at the Royal Academy which was then being generally raved over. 'It's rather a pity Impressionism happened,' he wrote.

'Out-of-door colours do not need to be gaudy – a mere dull stake of wood thrust in the ground often stands out sharper than the pink flashes of the French studio; a faggot; the outline of a leaf; low tints without reflecting power strike the eye as the bell the ear,' one of the great Ruralist heroes, Richard Jefferies wrote. 'For me they are intensely clear, and the clearer the greater the pleasure.'

Jefferies is very much claimed for the Ruralist camp. More nearly a contemporary than Wordsworth he catches for them not just the ecstasy of immersion in nature but the pathos of its vulnerability to passing time.

Nothing twice. Time changes the places that knew us, and if we go back in after years, still even then it is not the old spot; the gate swings differently, new thatch has been put on the old gables, the road has been widened, and the sward the driven sheep lingered on is gone. Who dares to think then? For faces fade as flowers and there is no consolation.

Jefferies was torn by the contradictions between the aesthetic beauty of nature and the harshness of the lives lived in it. The Ruralists are often accused of seeing nature as only a place of pastoral enchantment, an escape from the realities of their own time. But Blake and Palmer were looking back too. Even as the Industrial Revolution was tearing the traditional patterns of English rural life apart, they painted or engraved a classic landscape of Arcadian shepherds whose flocks graze amidst sacred groves.

The Ruralists are scornful of novelty for its own sake. They remain markedly unimpressed by the supposed leaders of the artistic van and the shifting patterns of label, taste, school and reputation among artists and galleries, which is fuelled by arts councils, academies, television and critics alike. Peter Fuller, their one-time scourge, liked to quote these words of Ruskin, and the Ruralists would heartily agree:

Originality in expression does not depend on invention of new words; nor originality on invention of new measures; nor in painting, or invention of new colours, or new modes of using them . . . Originality depends on nothing of the kind.

The Ruralists have turned their backs on what Giles Auty has called '. . . the empty rhetoric of progress which is abetted by a declared belief that only the most recent idioms are relevant to the age

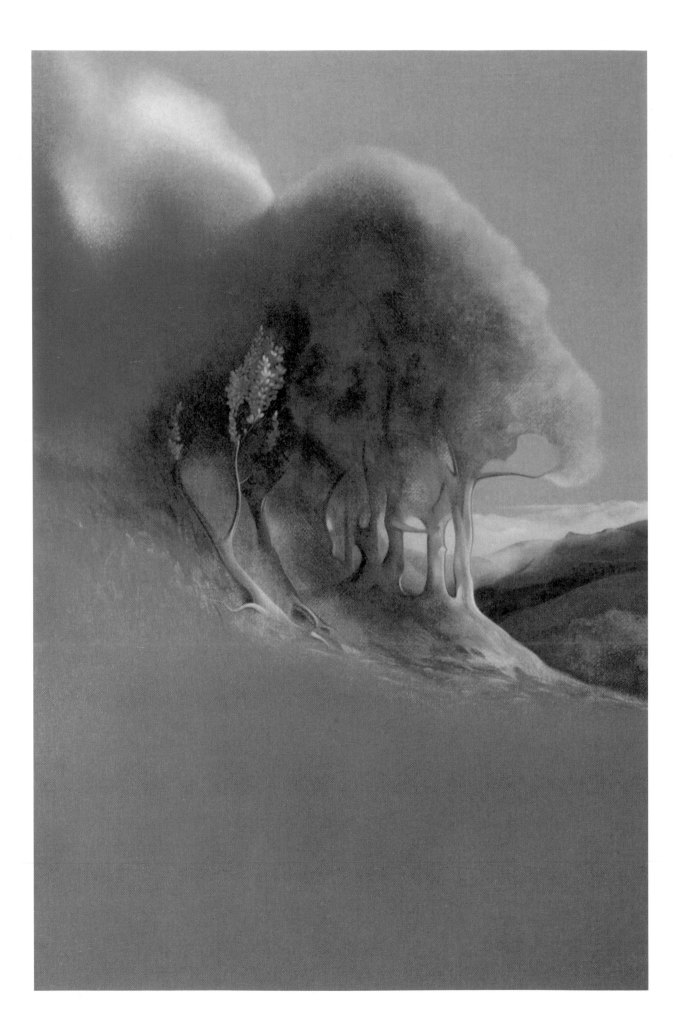

we live in.' The Ruralists' emblematic wielding of the names of Elgar, Wordsworth, Milton is not just cultural name dropping nor an attempt to seek legitimacy by association, but is an affirmation of the value and necessity of the cultural past in an age which seeks so often to distort or destroy it. In an age where so much is pretentious, ugly, inexplicable, and banal the Ruralists have held on to their ambition to paint something marvellous.

Can the Ruralists be blamed for not having the same intensity of expression as Blake and Palmer? One is irresistibly reminded of the high-spirited Ruralist holidays in Cornwall by accounts of Samuel Palmer and The Ancients rushing out of doors in Shoreham to embrace nature, almost overwhelmed by it. But Palmer didn't just give himself up to the power of nature in a spirit of pantheism; his and Blake's vision of the creation was shaped and suffused by their deep belief in Christianity. One evening, we are told, Blake was reading to Palmer the *Parable of the Prodigal Son*. But when he reached the words, 'And when he was yet a great way off, his father saw him . . .' he could go no further; his voice faltered and he was in tears. No artist can work entirely divorced from the beliefs and customs of his own age and it is the Ruralists' fate to work in an age which seeks to find not just an experience akin to religion in art but religion itself. It rarely produces art that itself attempts to convey a spiritual or religious truth.

So men go to church to find ritual, poetry, music and architecture and enter a gallery and hope to encounter imminence. 'People,' said Tom Wolfe, 'are judged not so much by their ethics anymore but by their aesthetics.' It is as if some sort of spiritual essence can be squeezed out of art uncontaminated by any of the inconvenient demands of belief or morality that traditional religions customarily exacted. By the same token nature has come to be worshipped for itself; not as the cosmic vessel of God's purpose for man, but in the fashionably green, 'Gaian' sense – a goddess.

And there, paradoxically, lies something of a reinstatement of Ruskin's view of nature as being 'moral'. Even if it no longer literally illustrates God's laws we perish if we flout or ignore our millennia-old responsibilities to her.

For all their particularity Blake, Palmer and the mystic interpreters of the English landscape were very influential; rather too influential, remarked Kenneth Clark. The Ruralists happily own that influence which was never extinguished for all the turmoil and tumult that was to overwhelm British art.

Have the Ruralists indeed tried to create for themselves in their veneration of nature an enclosed, secret garden; away from the fray, sheltered from the ignorance, the ugliness and the materialism of the times? If so, they have not always avoided paying the penalty of being regarded as marginal to the concerns of most people, of being on the periphery of things, producing, so to speak, blooms that are too delicate and private. But it has also given them a reasonable basis for a way of life as well as a basis for their art. Today a post-industrial world has become more cautious about the dangerous gifts of technology and more aware of the price in terms of pollution and waste that an urban, industrial society exacts. It is re-learning – none too soon – the value of the natural world and the necessity of re-establishing some sense of harmony with it. In such times the Ruralists assert something that goes beyond the limits of art. Richard Jefferies said, 'For the spirit of Nature stays and will always be there, no matter how high a pinnacle of human thought the human mind may attain; still the sweet air, and the hills, and the sea, and the sun, will always be with us.' For the Ruralists, Jerusalem has never been just a metaphor. Like all true artists they have tried to live up to their vision and that is not a small thing.

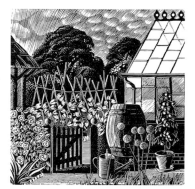

Graham Ovenden, The Druid's Grove, *1983, oil, 27.9x20.3cm*

John Morley, Out in the Garden, *1990, wood engraving*

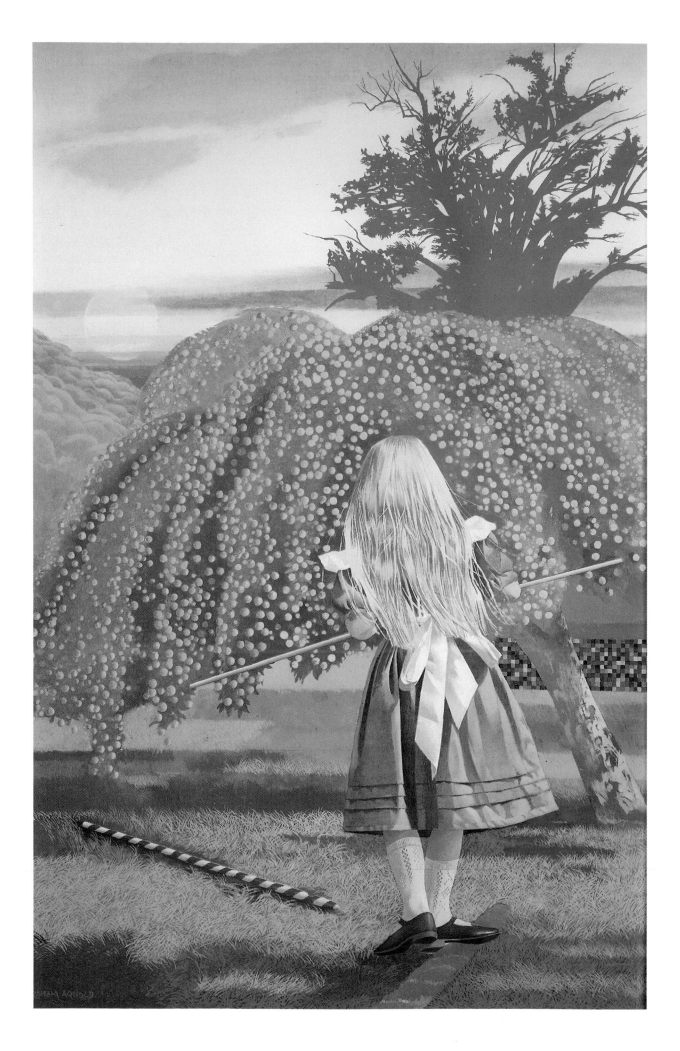

ALICE

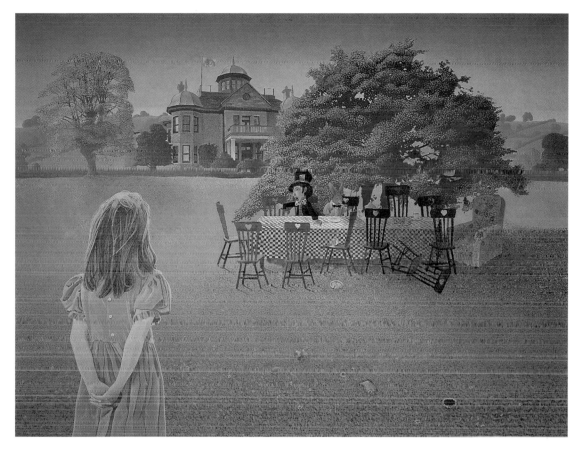

Graham Arnold, Alice Balances, 1990, oil

Annie Ovenden, Lot 106 – A Mad Hatter Tea Party, *1990, oil on panel*

There was a table set out under the tree in front of the house, and the March Hare and the Hatter were having tea at it: a Dormouse was sitting between them, fast asleep, and the other two were using it as a cushion, resting their elbows on it, and talking over its head. 'Very uncomfortable for the Dormouse,' thought Alice; 'only, as it's asleep, I suppose it doesn't mind.'

The table was a large one, but the three were all crowded together at one corner of it. 'No room! No room!' they cried out when they saw Alice coming. 'There's *plenty* of room!' said Alice indignantly, and she sat down in a large arm-chair at one end of the table.

'Have some wine,' the March Hare said in an encouraging tone.

Alice looked all round the table, but there was nothing on it but tea. 'I don't see any wine,' she remarked.

'There isn't any,' said the March Hare.

'Then it wasn't very civil of you to offer it,' said Alice angrily.

'It wasn't very civil of you to sit down without being invited,' said the March Hare.

'I didn't know it was *your* table,' said Alice; 'it's laid for a great many more than three.'

Lewis Carroll, 'A Mad Tea Party', Alice's Adventures in Wonderland

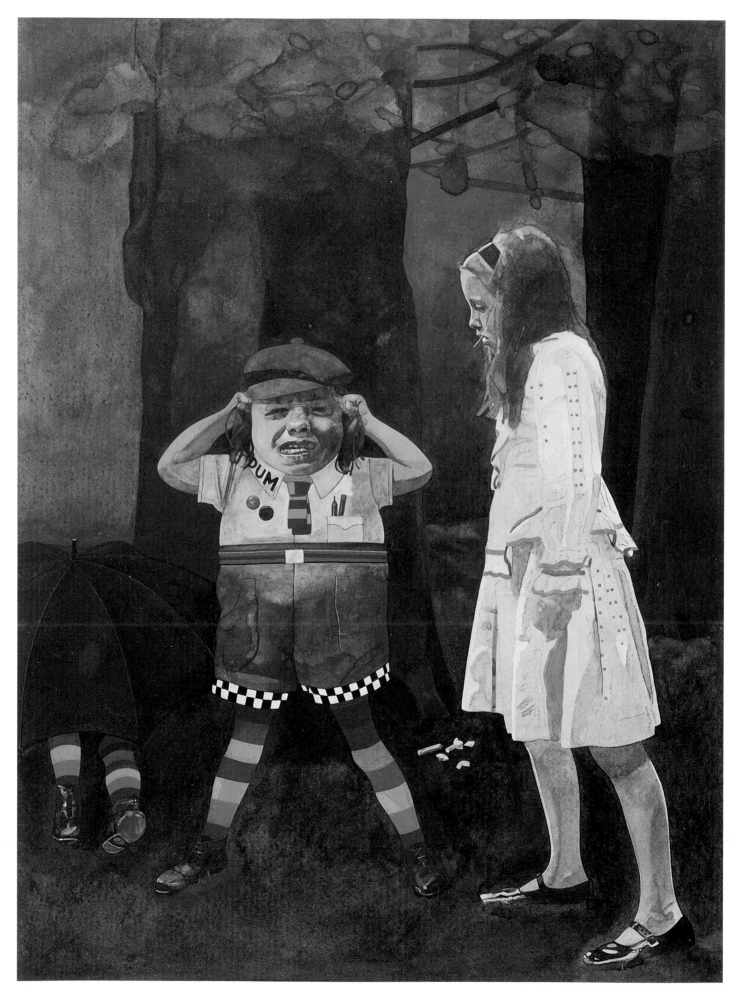

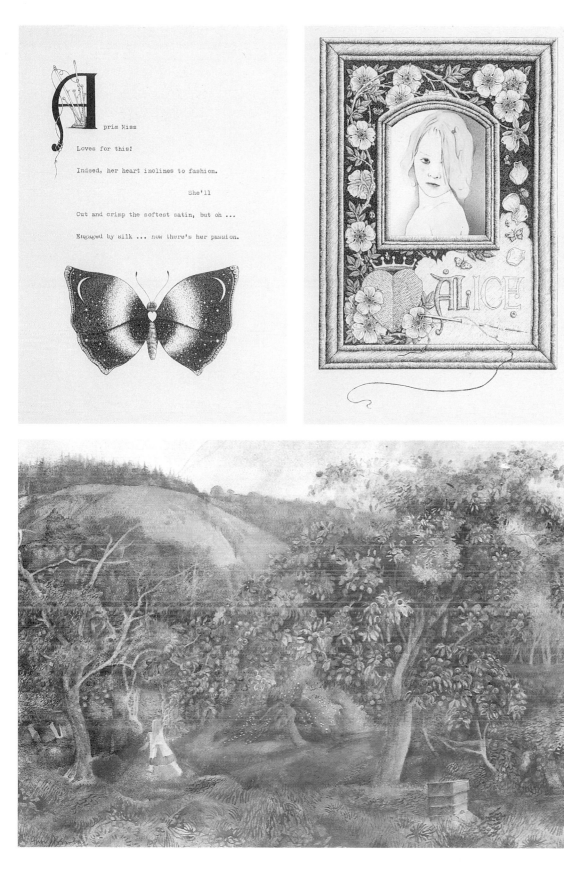

A prim Miss

Loves for this!

Indeed, her heart inclines to fashion.

She'll

Cut and crimp the softest satin, but oh ...

Engaged by silk ... now there's her passion.

Peter Blake, 'But it isn't old' Tweedledum cried…, *1970-71, watercolour, 25.4x20.3cm*

Graham Ovenden and Brian Partridge, pages from A Book of Acrostics, *1986, pen and ink, 17.8x12.7cm each page*

Ann Arnold, The Red Queen, *1990, watercolour*

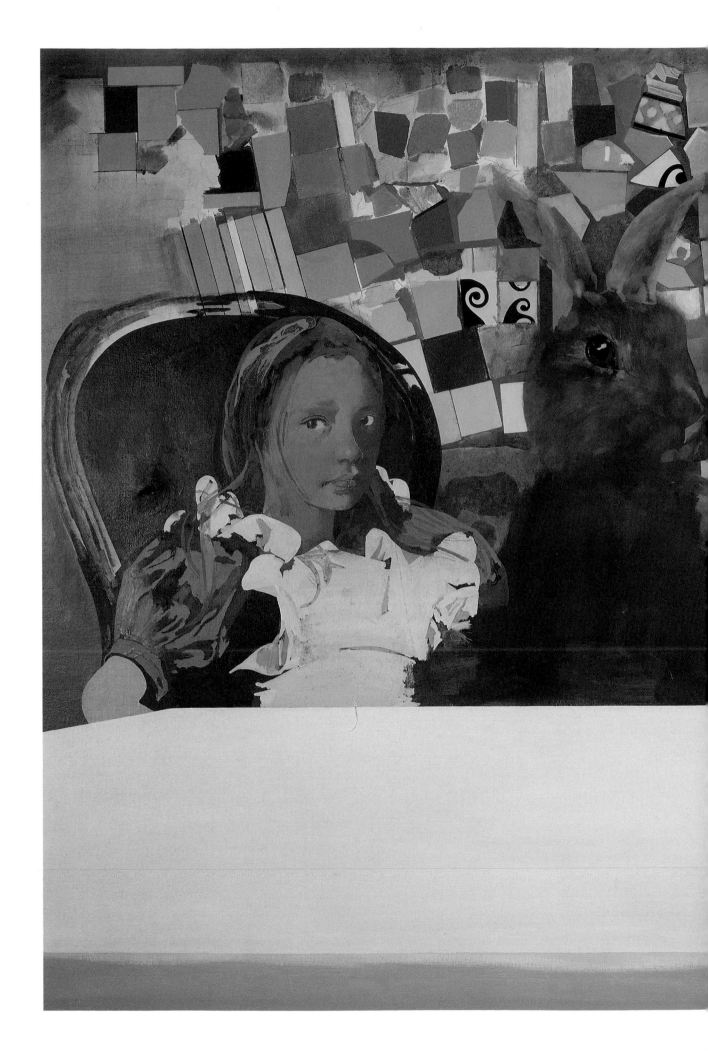

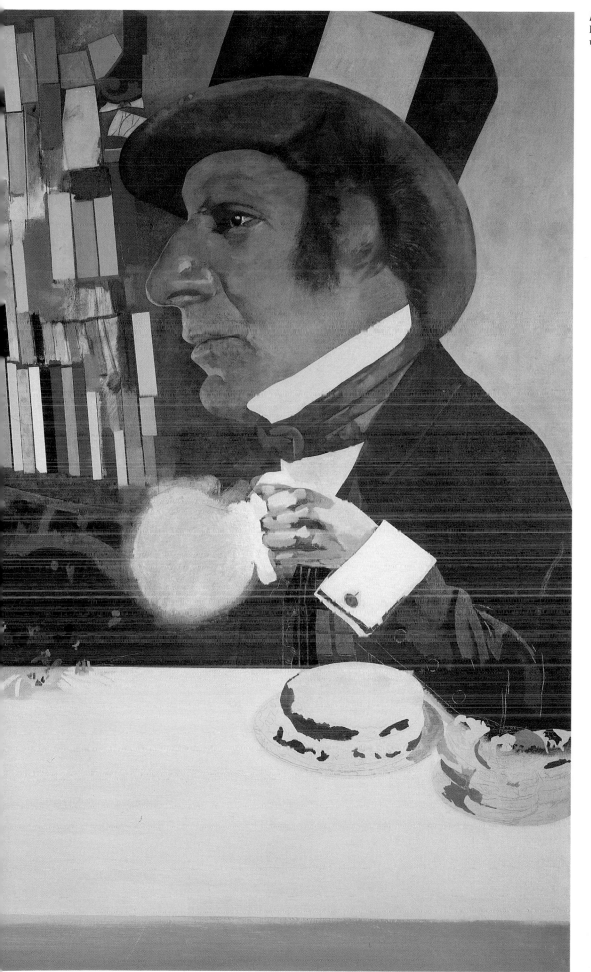

Peter Blake, The Mad Hatter's Tea Party at Watts Towers, *1970-71, watercolour and collage*

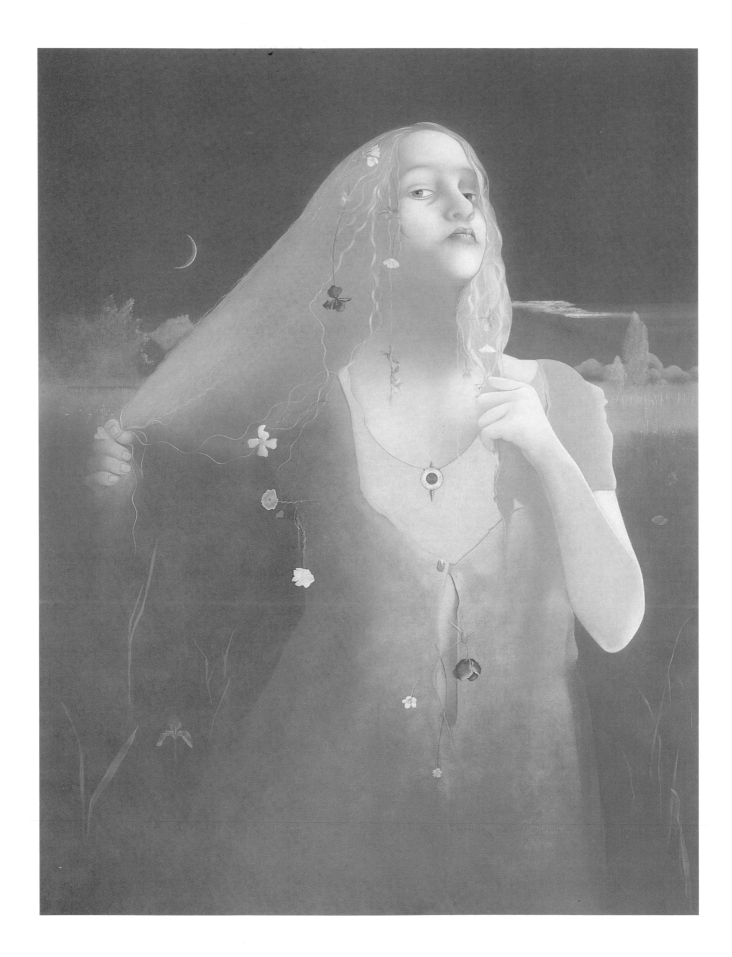

OPHELIA

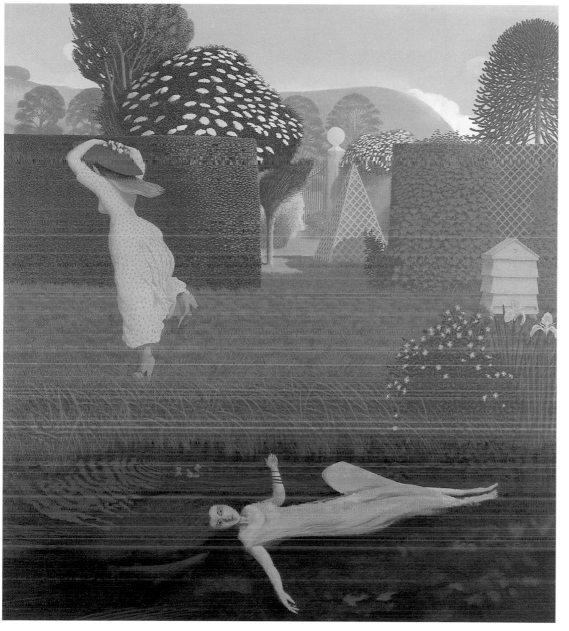

Graham Ovenden, Ophelia, *1980-81, oil on canvas, 88.4x67.6cm*

David Inshaw, The River Bank (Ophelia), *1980, oil, 129.5x119.4cm*

OVERLEAF: Annie Ovenden, Ophelia, *1979-80, oil on hardboard, 91.5x76cm*

Peter Blake, Ophelia, *1979, work in progress, oil on board, 137.2x94cm*

One Ruralist theme, consciously echoing the Pre-Raphaelites, is Shakespeare's Ophelia, the subject of a 1980 exhibition in the Wren Library, Trinity College, Cambridge. Nicholas Usherwood highlights the individual concerns of the artists: Peter Blake's *Ophelia* he describes as 'a dark, sombre painting, an image of mental anguish and suffering'; in Graham Arnold's work he finds 'a softness of tone that captures the erotic nature of the subject perfectly'; while Annie Ovenden has a 'deep understanding of children and child-like qualities that makes her Ophelia such a memorable image, capturing the fragile balance between the physical maturity of her body and still childish emotional innocence.'

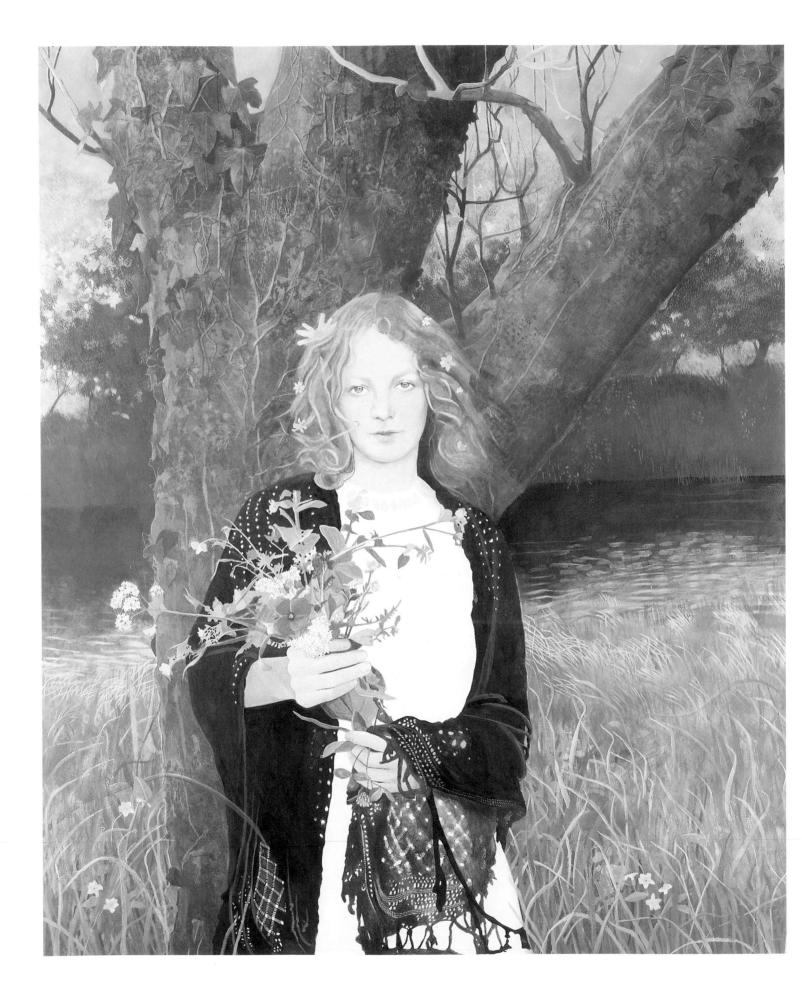

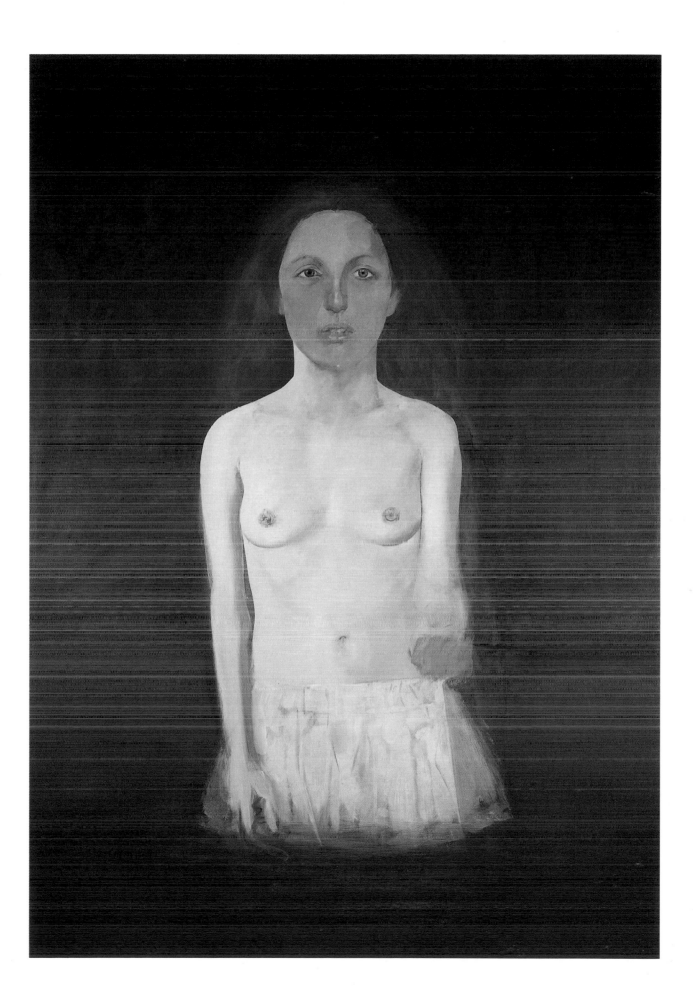

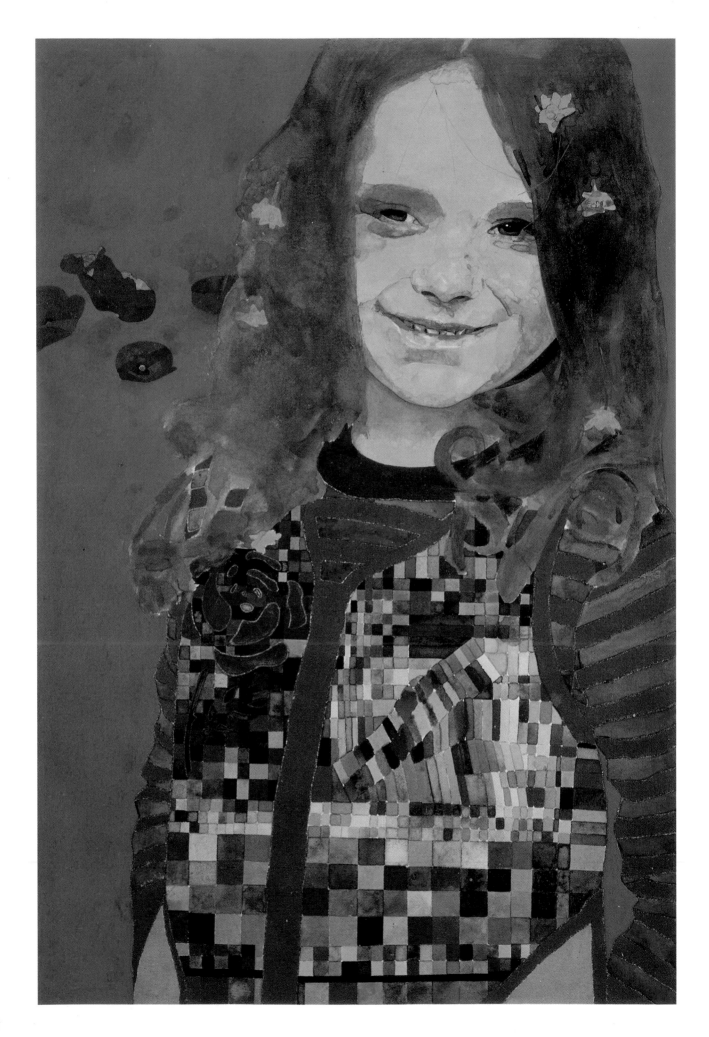

PETER BLAKE

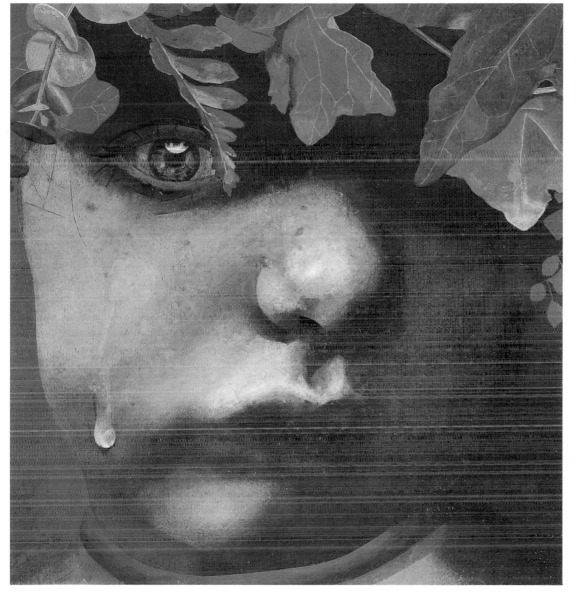

Girl in a Poppy Field, *1968-69,*
watercolour, 40.6x29.2cm

Fairy Child Crying, *work in progress,*
oil, 15.2x15.2cm

OVERLEAF: Portrait of David
Hockney in a Hollywood-Spanish
Interior, *begun 1965, Cryla,*
182.9x152.4cm

Daimler, *1980, oil*

The marriage of disparate elements to make a convincing whole is a way of visual thinking that has been a consistent characteristic of Blake's art. Much of his work mingles fantasy with reality: he gives to the truly fanciful a convincing edge of reality.

Blake's well-known fascination with *Alice in Wonderland* and *Through the Looking Glass* has been complemented with an intense interest in the world of 'faeries', from *Titania* (begun 1972) on. These seem typically English fantasies, robustly rooted in the absurdities of reality. Like art itself, both 'faery' and 'Wonderland' are richly referential to the real world.

Blake's art, seen as a whole, is at the absolute centre of the English tradition . . . alongside his world of artifice and imagination is an exceptionally acute sense of observation. *Marina Vaizey*

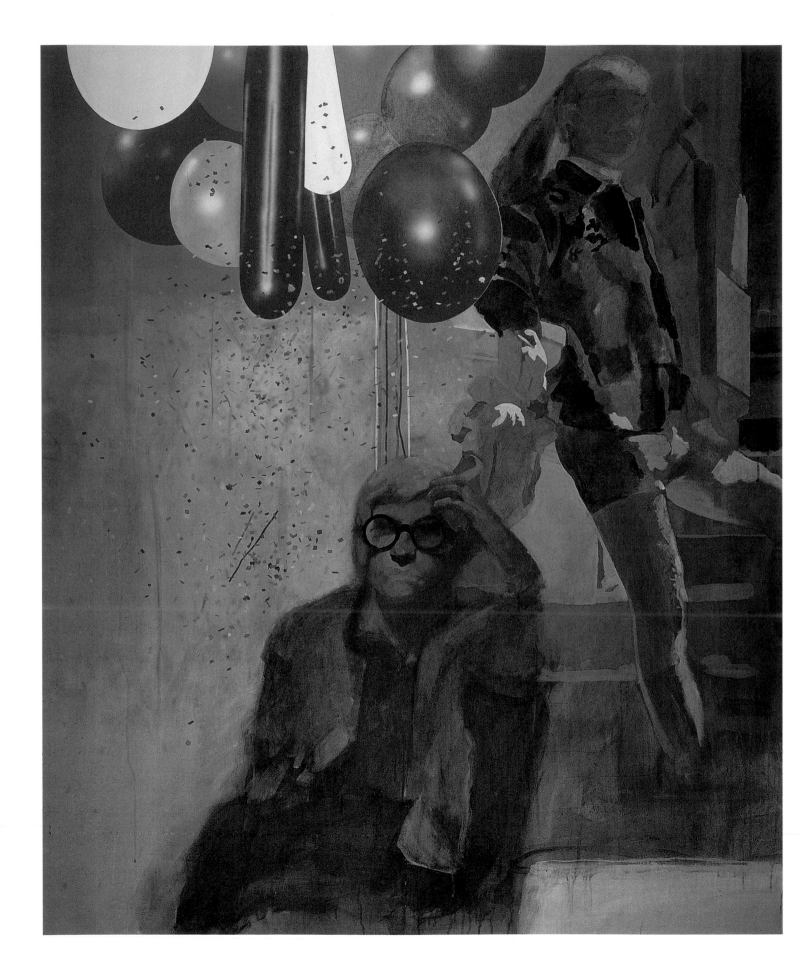

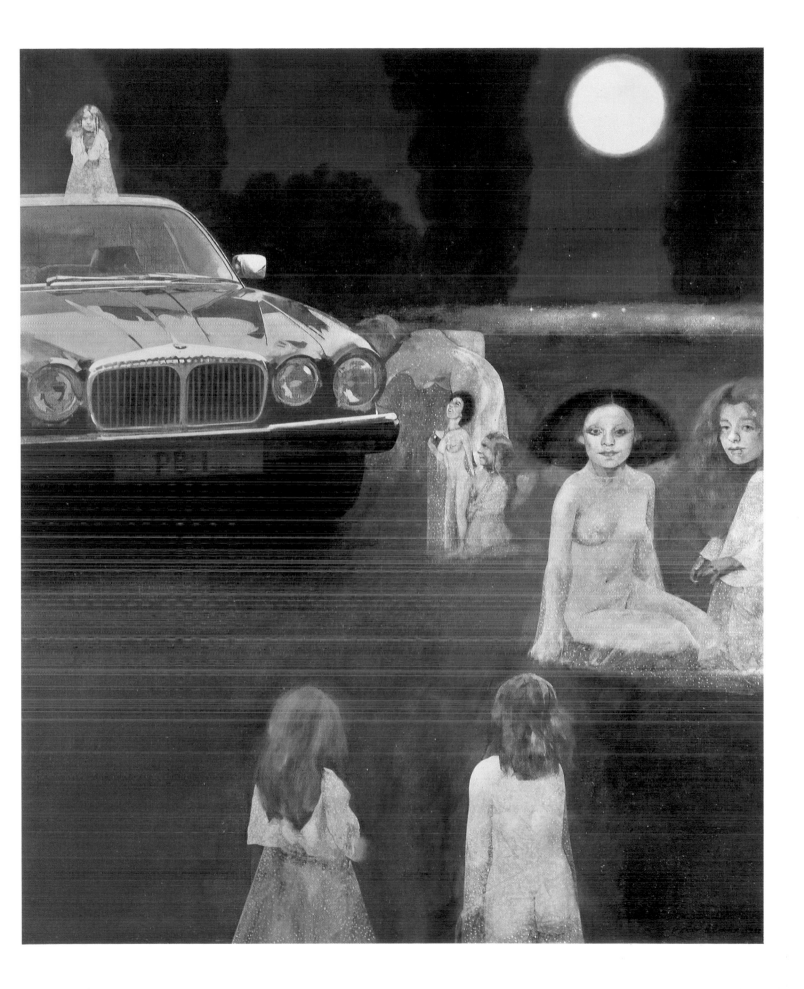

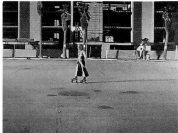

A Remembered Moment in Venice
California, *work in progress, oil*

OVERLEAF: 'Well, this is grand!'
said Alice..... *1970-71, watercolour,
25.4×20.3*

*Fairy, 1972-76, watercolour on paper,
20.9×13.3 cm*

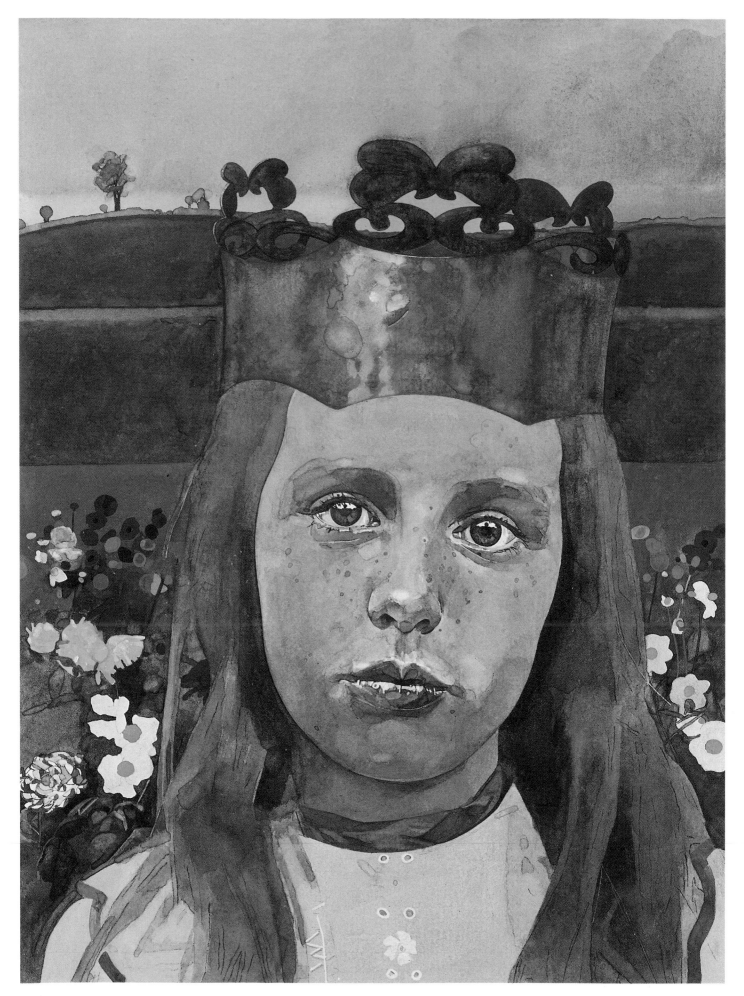

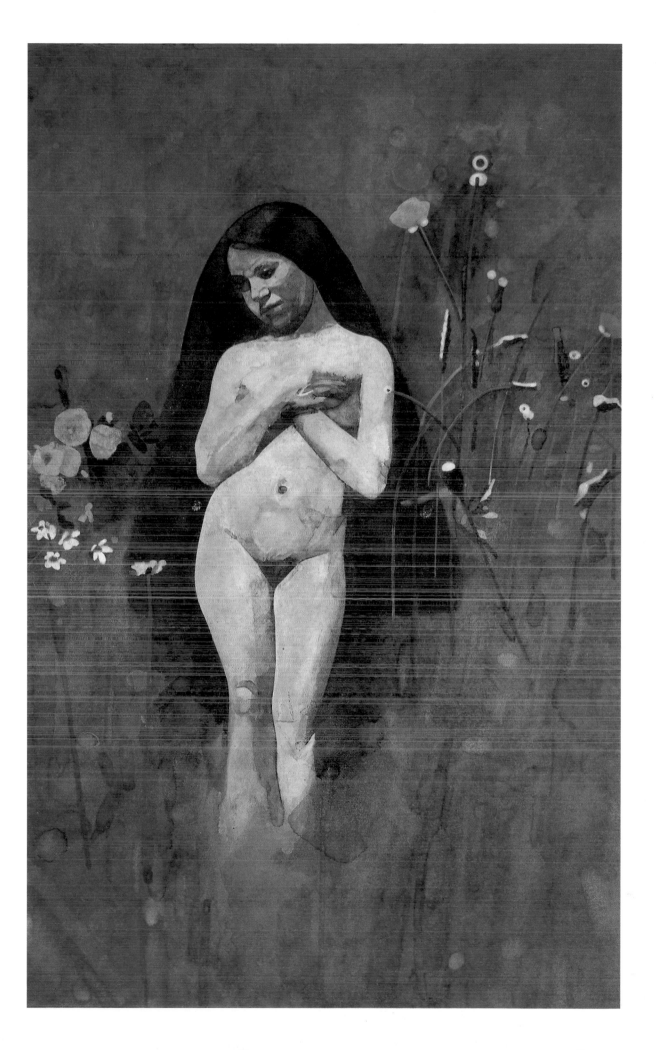

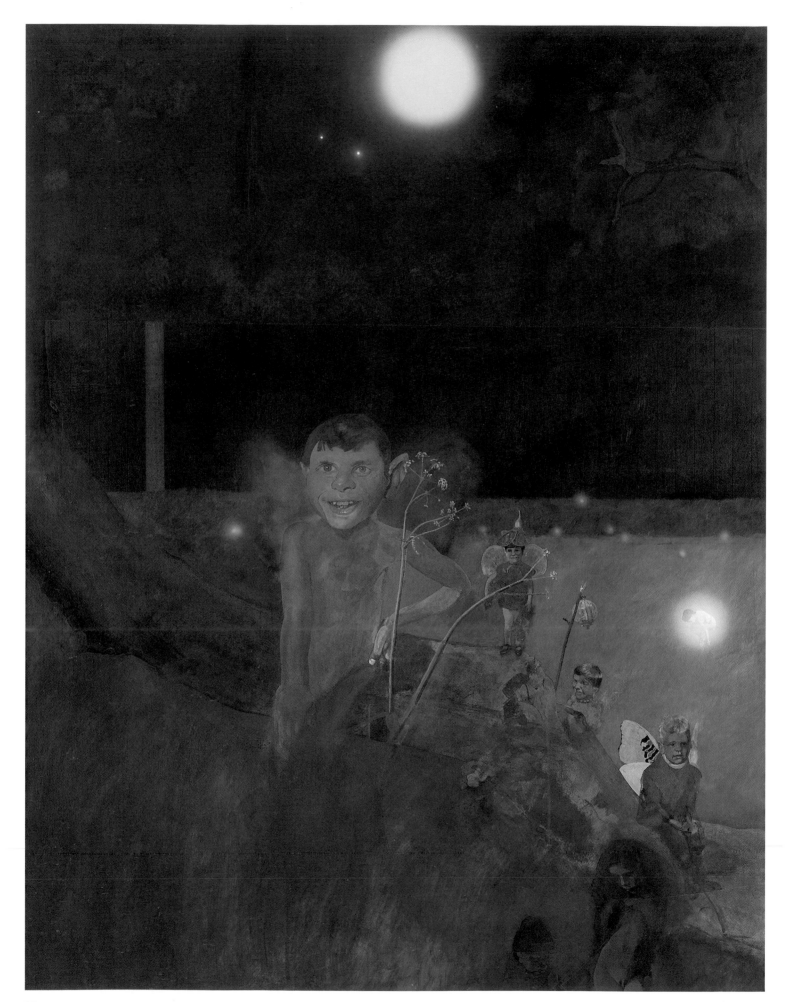

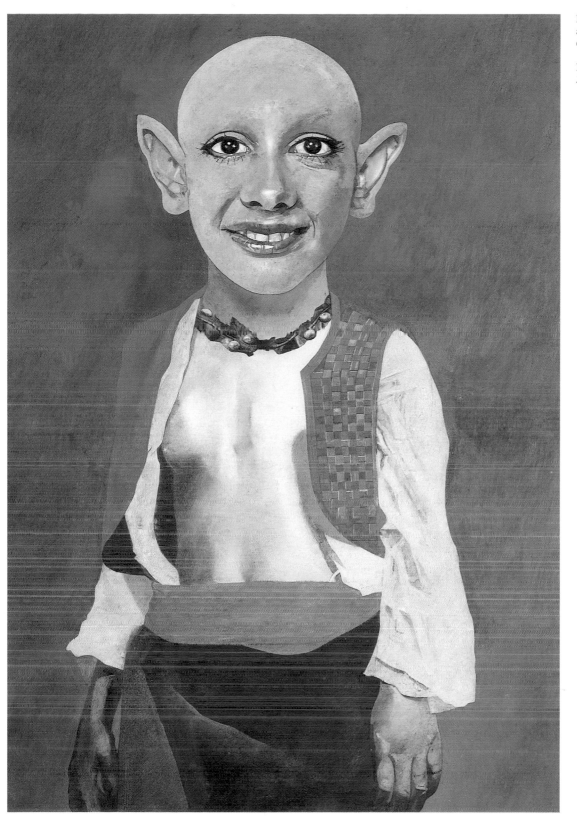

Puck, Peaseblossom, Cobweb, Moth
and Mustardseed, *work in progress,
Cryla on hardboard, 99x76.2cm*

Nadia, *1981, oil on board,
29.2x21.6cm*

GRAHAM OVENDEN

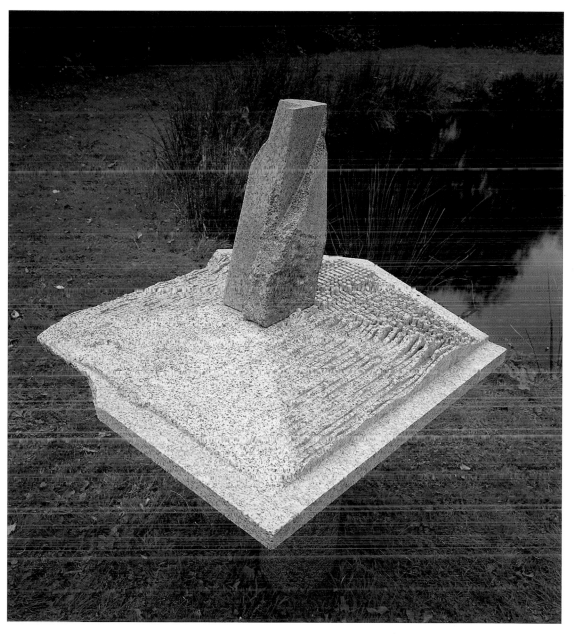

Towards the Sea, *1990, oil, 47x39.4cm*

The Perspective of Time (The Tower of Babel), *1987, polychromatic granites, base 80x84cm, height 54cm*

OVERLEAF: Katy, *1987, oil on panel, 31.8x25.4cm*

Emily Alice Ovenden, *1987, oil on panel, 90.2x61cm*

Ruralism is a conscious effort to regain at least a modicum of grace. We may call its emotional response Romantic, visionary, colour expressionism, but underlying all is that first formative awareness.

It may well be that the Ruralists' self-conscious efforts to pare away our base metropolitan values, seeking, if you will, rock and earth as opposed to concrete, are a source of strength. Ruralism, whatever its Romantic connotations, is not the soft underbelly of contemporary art. The opposite in fact is the case. Light plays on form, creating shadow and mystery. Ruralism is no less sensible to this disquieting interplay than it is to the prismatic ecstasy of the natural world. *Graham Ovenden*

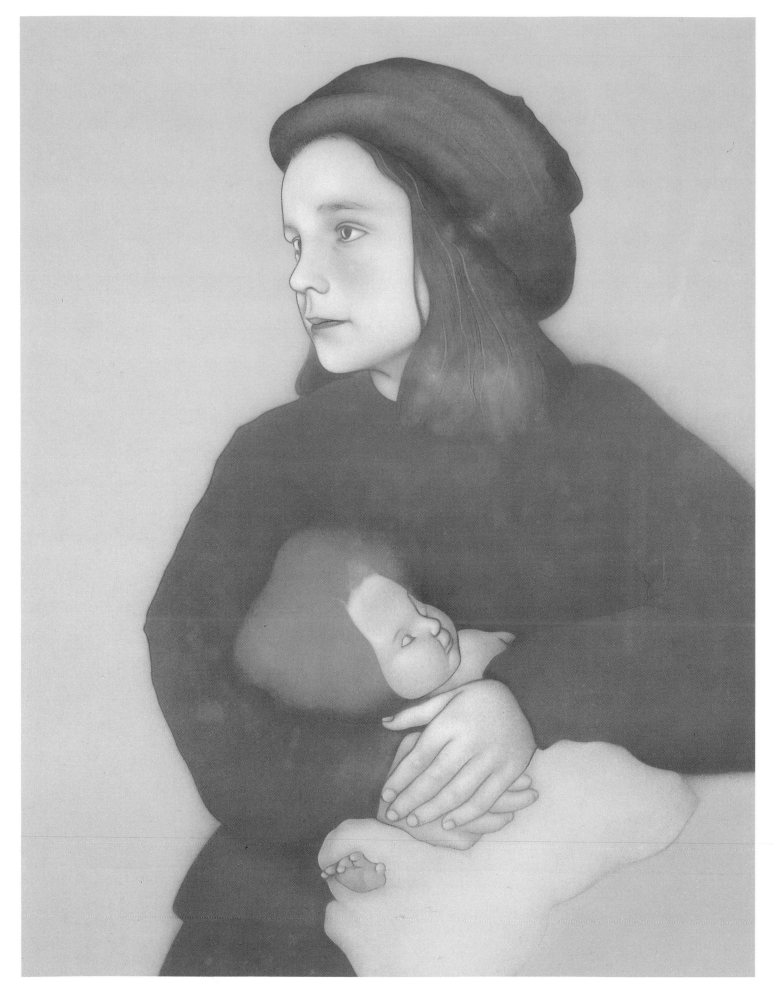

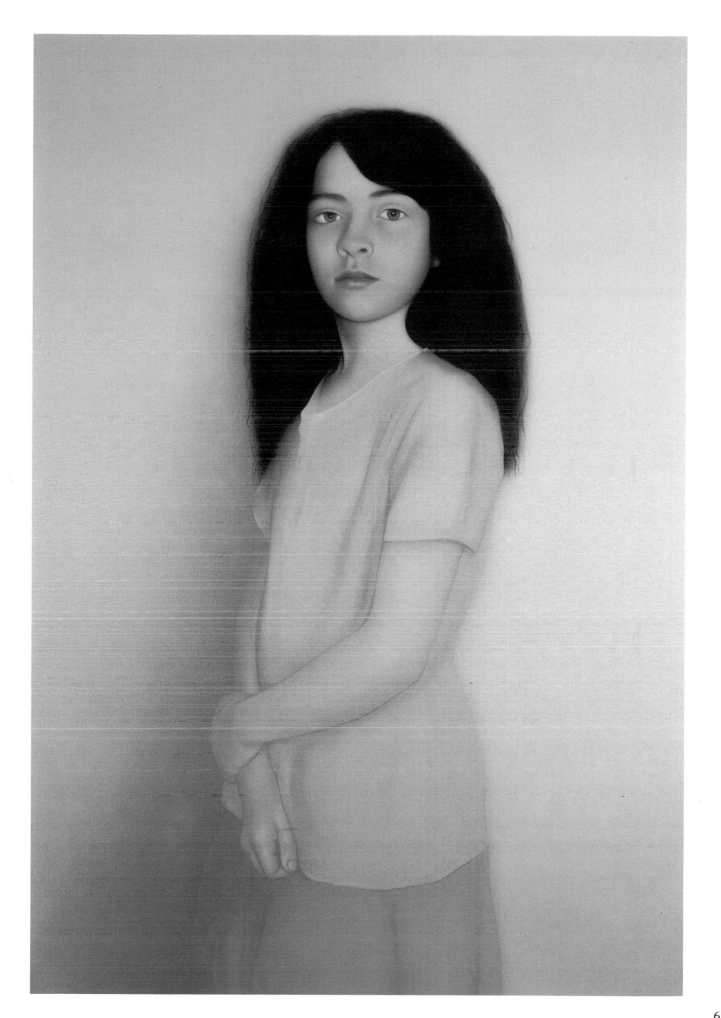

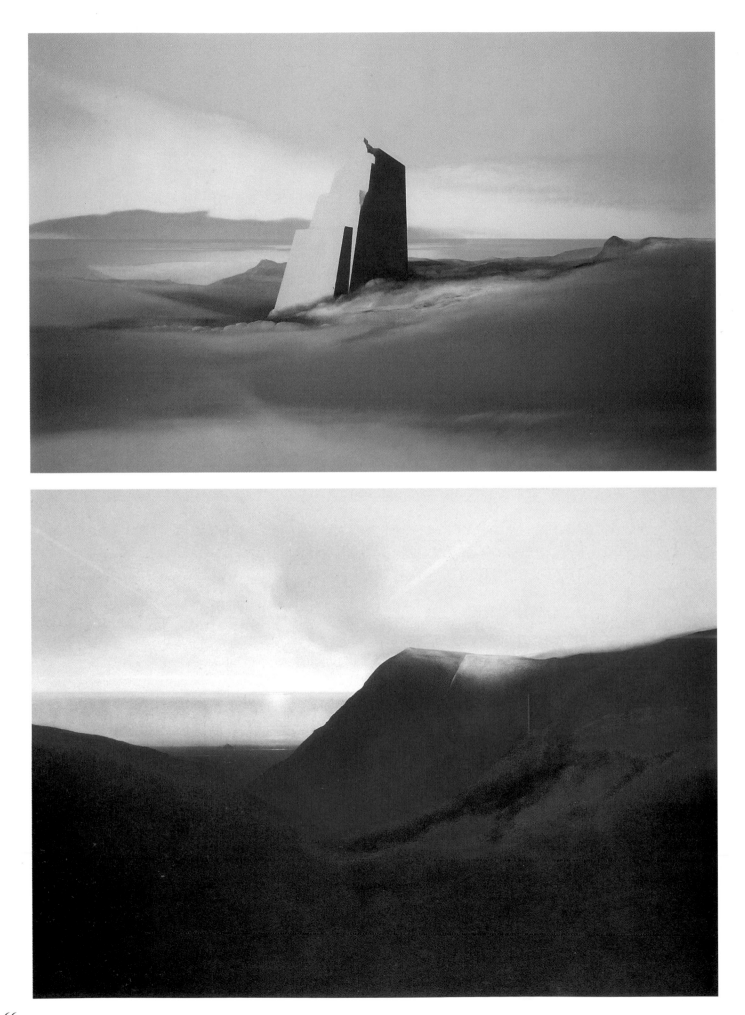

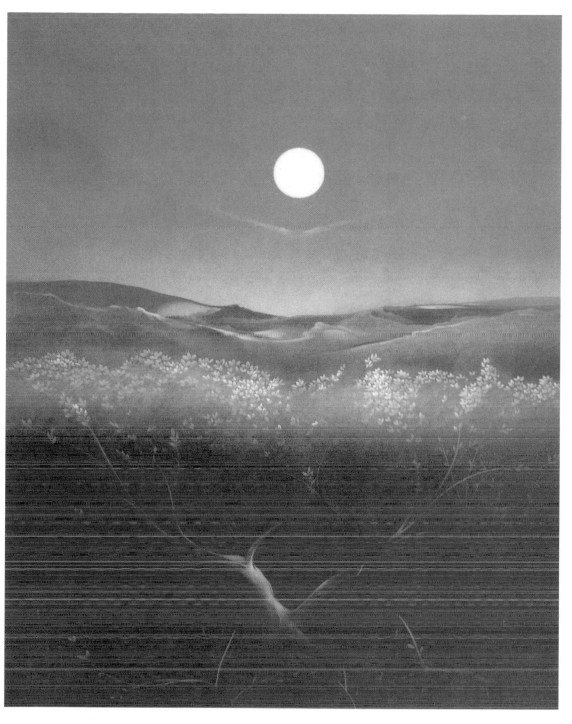

The Tower of Babel, *1984-85, oil,*
121.9x203.2cm

The Residence of the Philosopher
Kemp, *1984, oil on panel,*
54.6x73.7cm.

Full Moon, *1983, oil on panel,*
29.2x23.5cm

OVERLEAF: Self-Portrait, *1990, oil*

Girl in the Shadows, *1990, oil,*
33x31.8cm

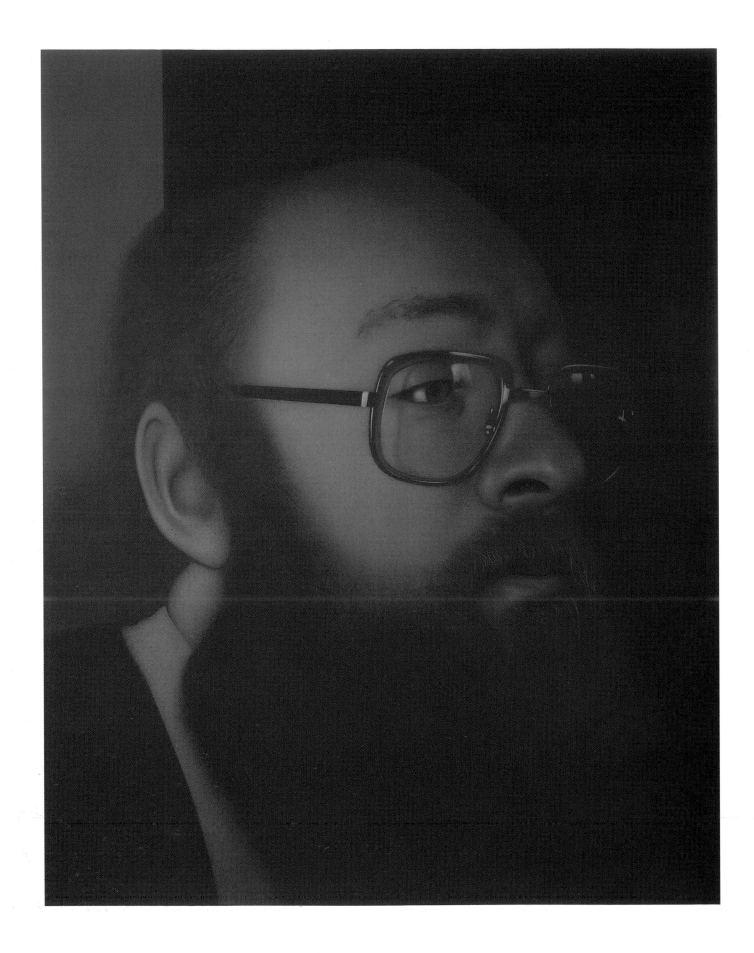

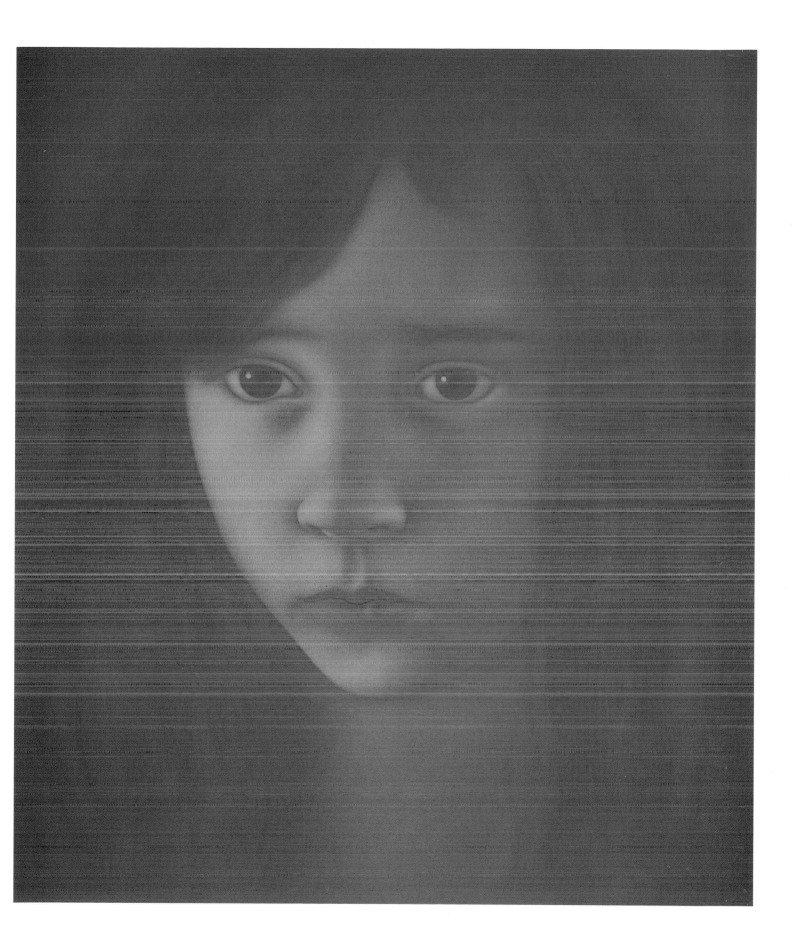

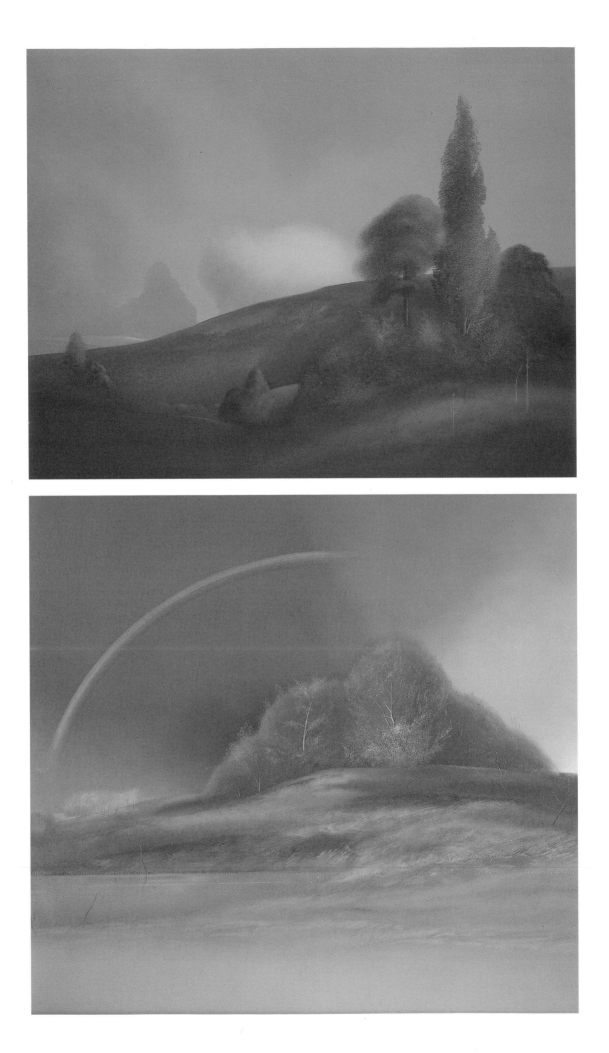

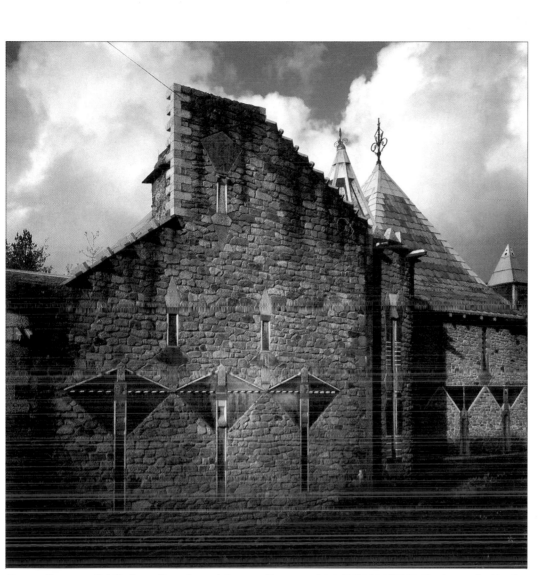

For me the essential Graham Ovenden exists more than anywhere in Barley Splatt, the house that he has been building since he moved to Cornwall in 1973. It is not only that architecture was regarded as the Mistress Art by Ovenden's 19th-century heroes, but also that in the house, the many enthusiasms of his life, all the different directions of his work, all the engaging facets of his thought, come together and form a pattern – the pattern of Ovenden's total artistic personality. The house, in this case, is the man.

Barley Splatt is like no other house. It is rich in its textures, almost barbaric in its glowing colours, fantastic in its weird, evolving forms.

In its very bones Barley Splatt is a collector's house, for some of the fragments that Ovenden has snapped up over the years have been built into and used to ornament that structure. Just as no true collection ever reaches a fixed and final point, so the house seems to be locked, almost one might think forever, into a state of evolution. *Clive Aslet*

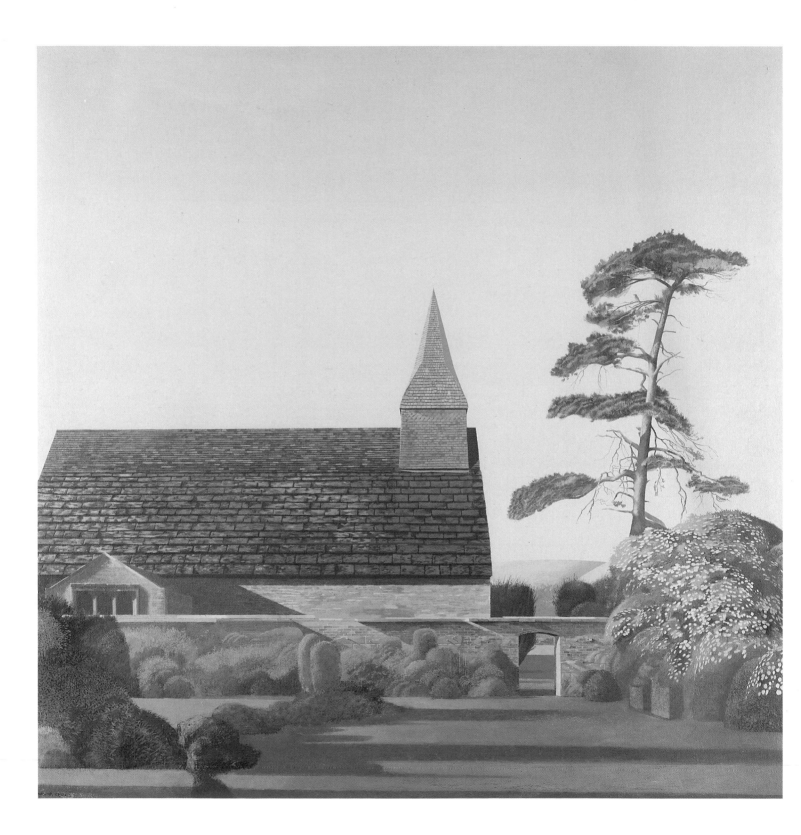

72

GRAHAM ARNOLD

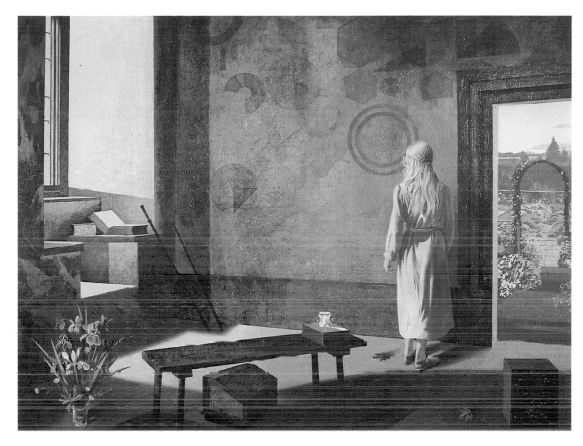

The Church at Warminghurst, West Sussex, *1974, oil*

The Study, *1989, oil*

OVERLEAF: The Dream Child, *1990, oil*

Garden of Loves, *1987, collage construction*

Graham Arnold's paintings combine warmth and poetry with mysteriousness and a metaphysical quality. His compelling images have a monumentality and a dream-like character. His imagery owes a great deal to the inspiration of certain poets, in particular John Clare, TS Eliot, Thomas Hardy, Richard Jefferies, Edward Thomas and Wordsworth, and to music, which is a constant passion. As well as painting large compositions which are highly complex and consist of many small sections within an overall scheme, he also paints landscapes, such as *Warminghurst Church*, still lifes and collages, which are an important, if more private, side of his work. *Caroline Odgers*

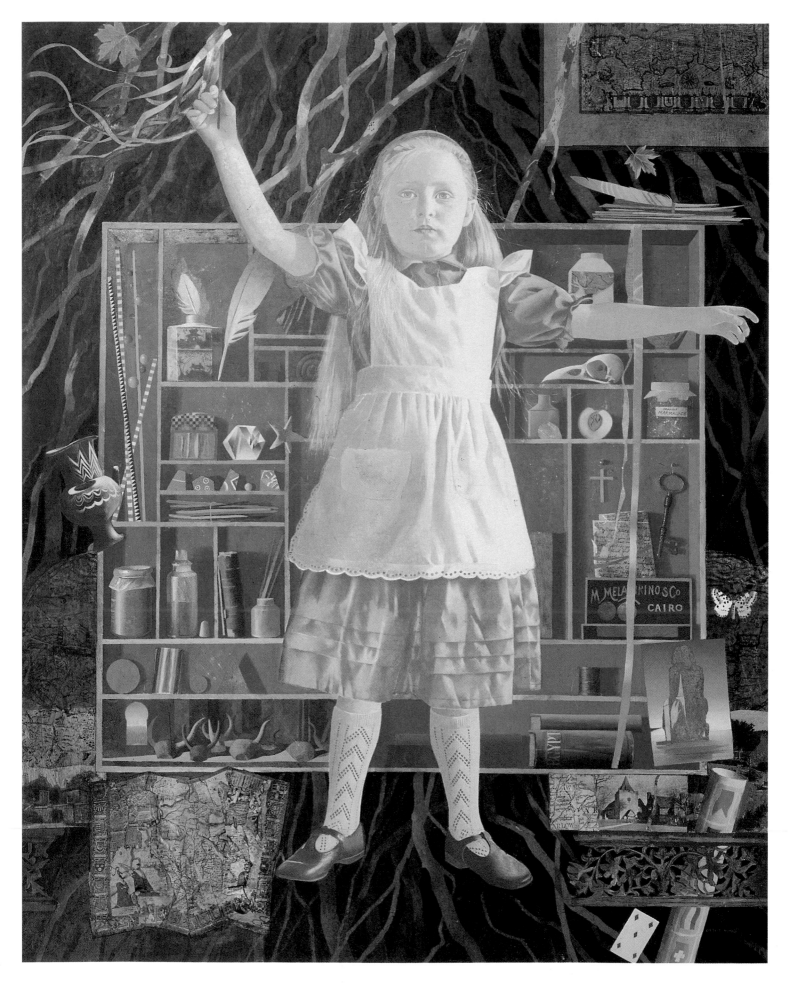

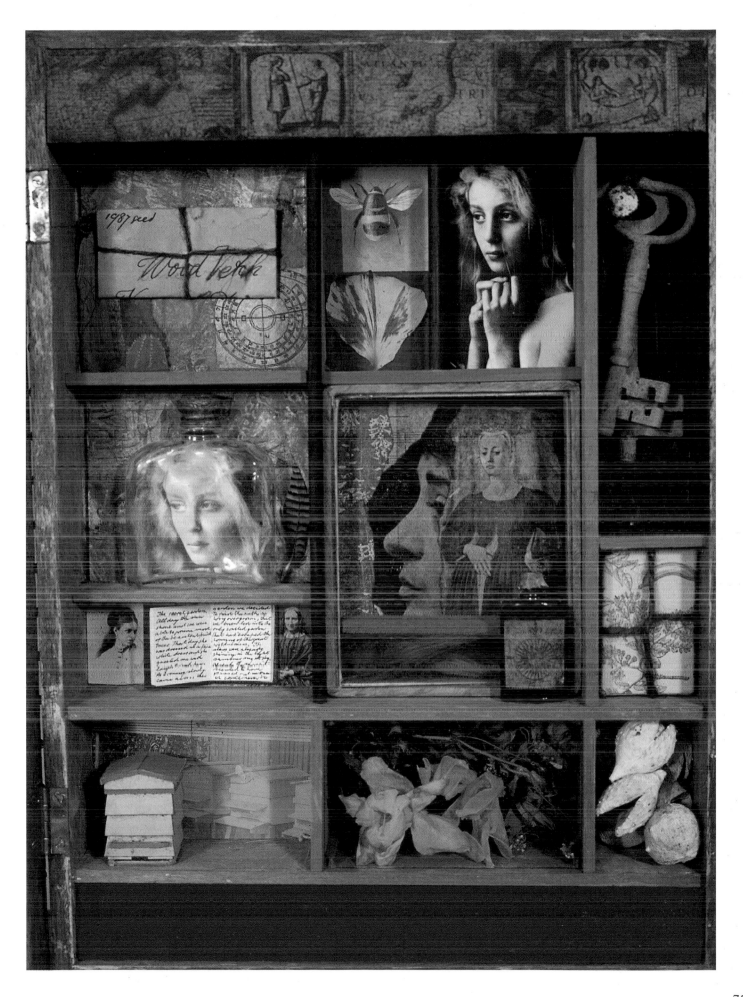

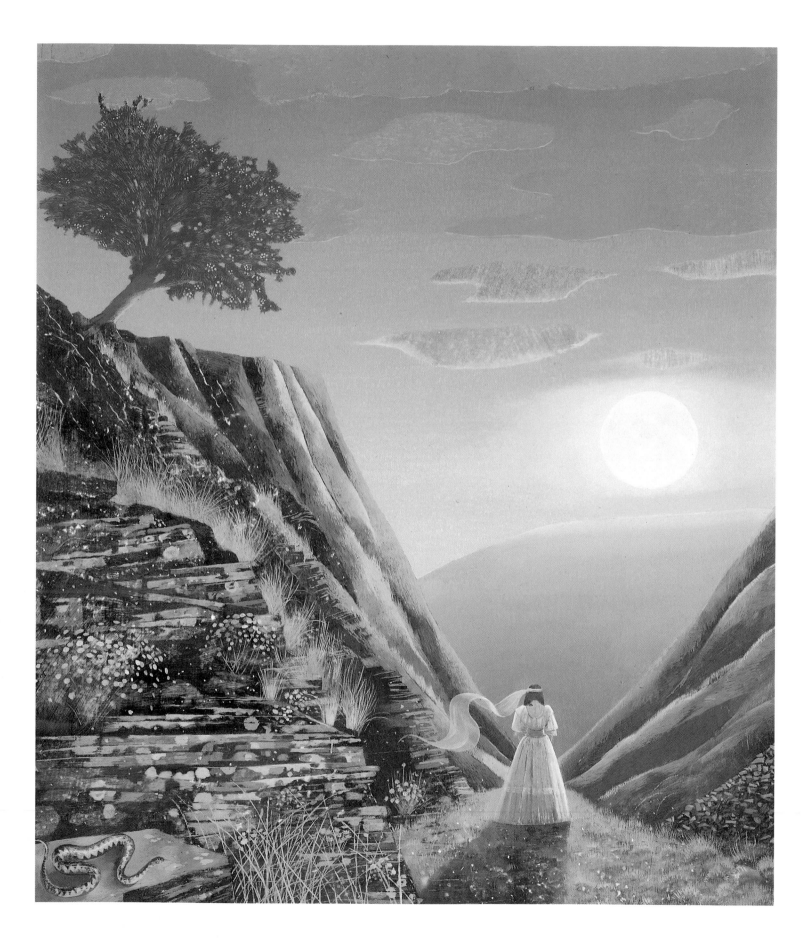

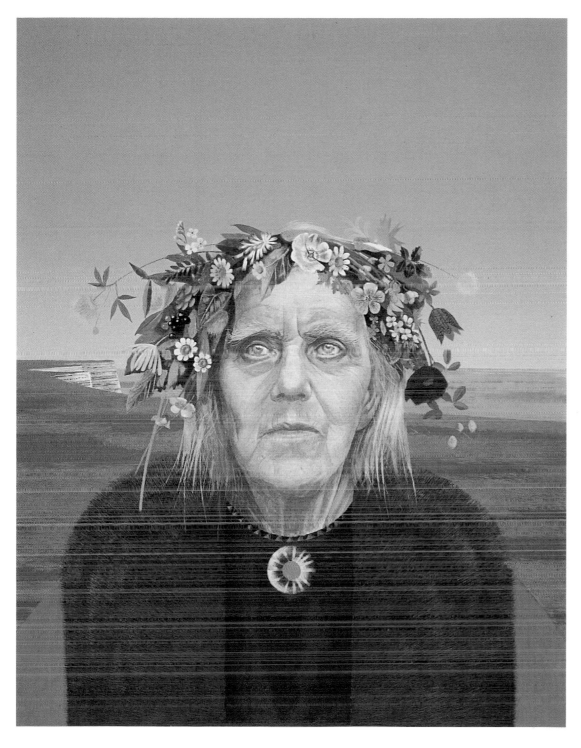

The Bride on the Hill, *1987, oil*

Queen Lear, *1986, oil*

OVERLEAF: Rose Spectrum, *1987, oil*

Emblems of Enchantment, *1989, oil*

Divided Paradise, *1988-89, oil*

Memorials of a Quiet Life, *1976, oil*

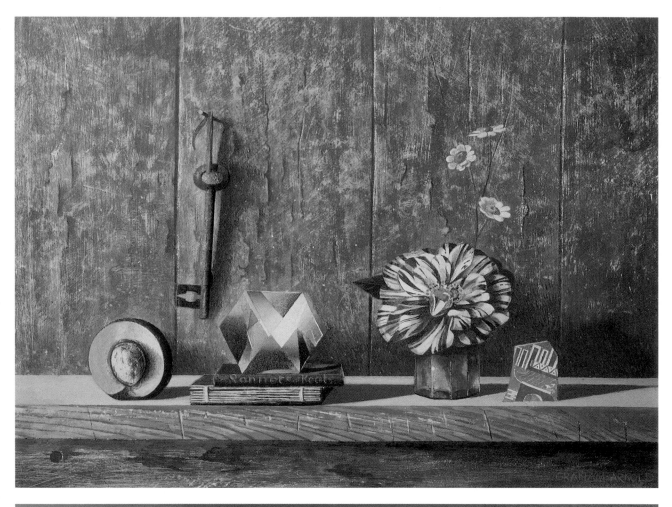

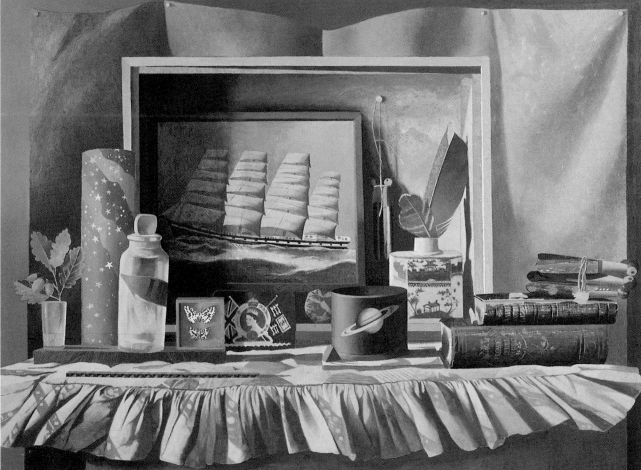

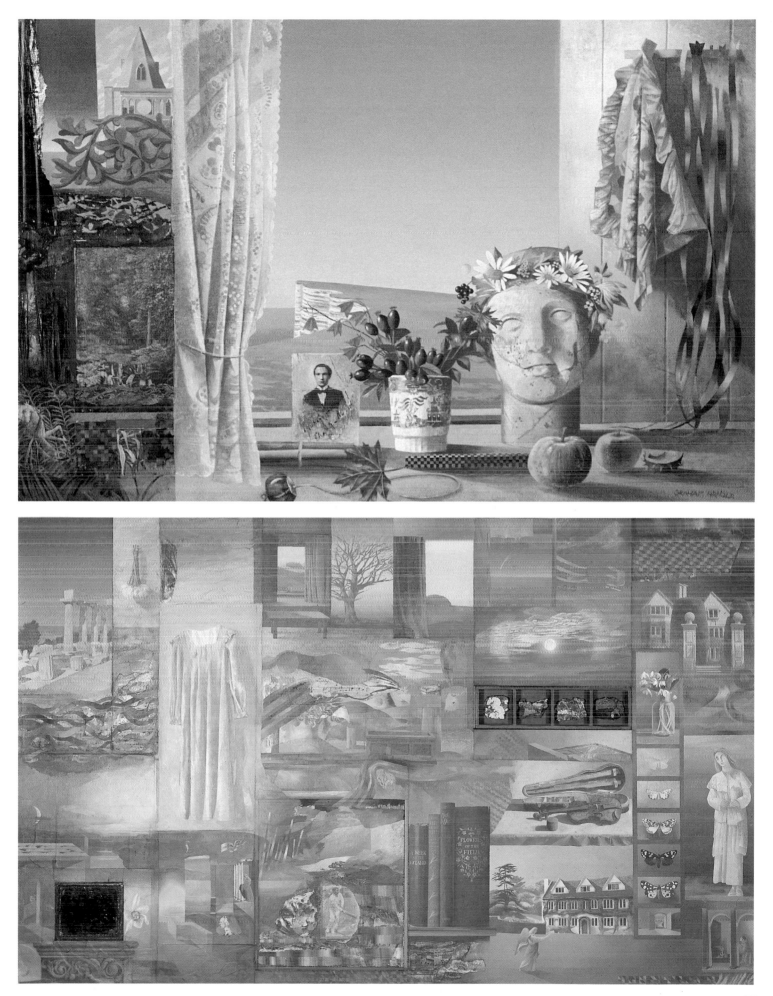

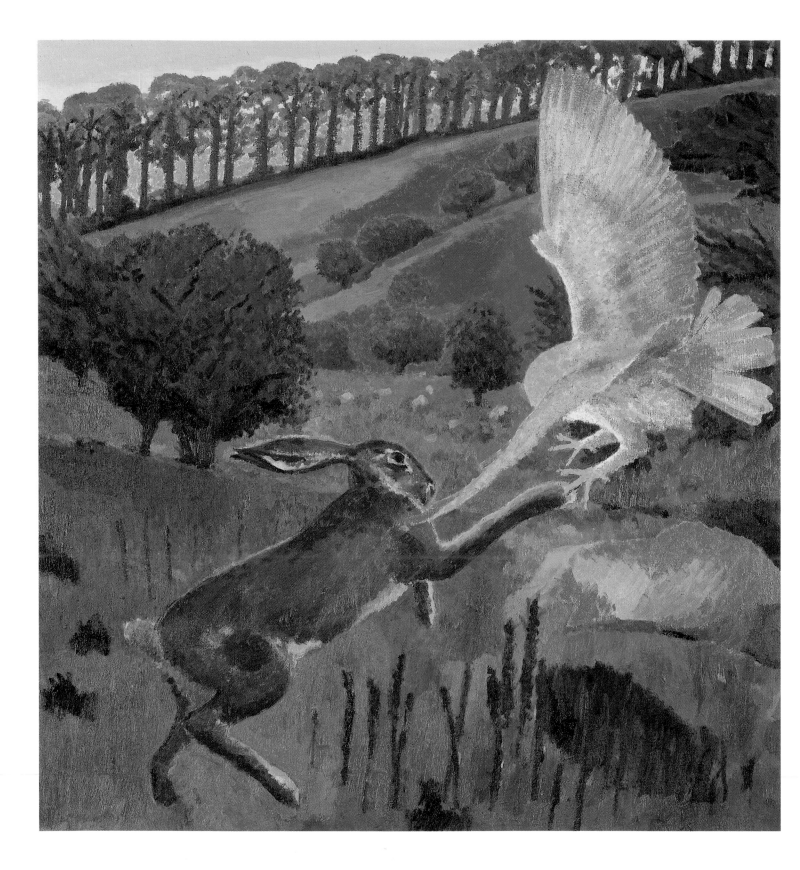

DAVID INSHAW

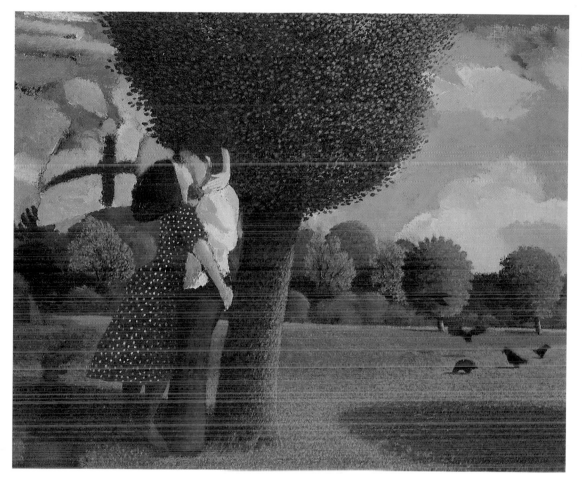

Incident in the Landscape, *1988-89, oil, 76.2x71.1cm*

Lovers near Kew Gardens, *1976, oil, 31.7x36.8cm*

Reacting to the comparative freedom he found at the Royal Academy Schools, David Inshaw abandoned the heavy impasto paint, the traditional subject-matter of the nude and still-life for a more Pop-oriented method of working; its more experimental and subjective approach being better suited to the expression of personal feelings he now wanted his work to contain. The physical making and doing of the picture became very important, and he started to use collage, silk-screen, *papier collé* along with constructed elements and assemblages of objects. It was not until he left the Royal Academy Schools in 1966 and went to live and teach in Bristol that landscape began to appear for the first time in his work. At the same time the Pop elements began to disappear so that by 1970, he too stopped using Cryla paints as too hard and insensitive a medium for the full-scale landscapes that he now wanted to tackle. It was at about this time that he started to discover the great writers on the countryside, Thomas Hardy in particular. The excitement that he felt on reading Hardy, the chords of feeling and sentiment that Hardy's approach to his subject-matter struck in him, only served to confirm his growing instinct that it was in the more conventional theme of landscape with figures that he would find a way of painting best suited to expressing his intense personal feelings. *Nicholas Usherwood*

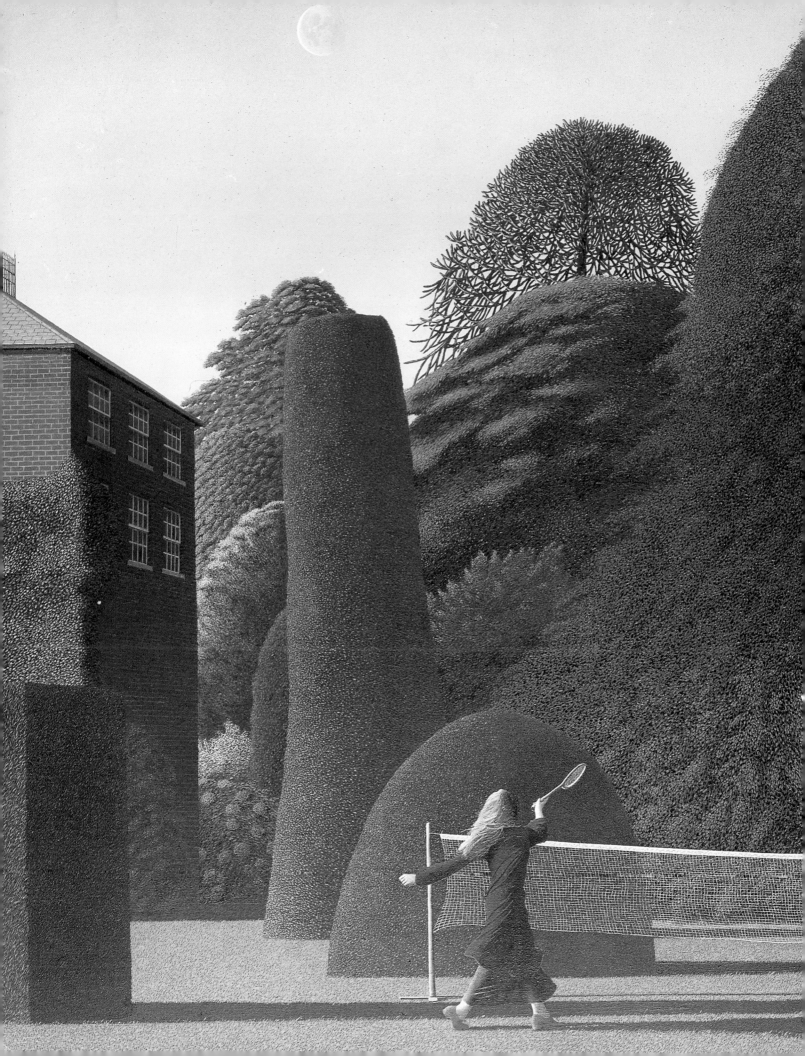

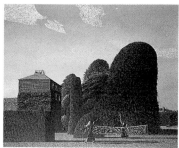

The Badminton Game, *1972-73, oil,*
152.4x182.2 cm

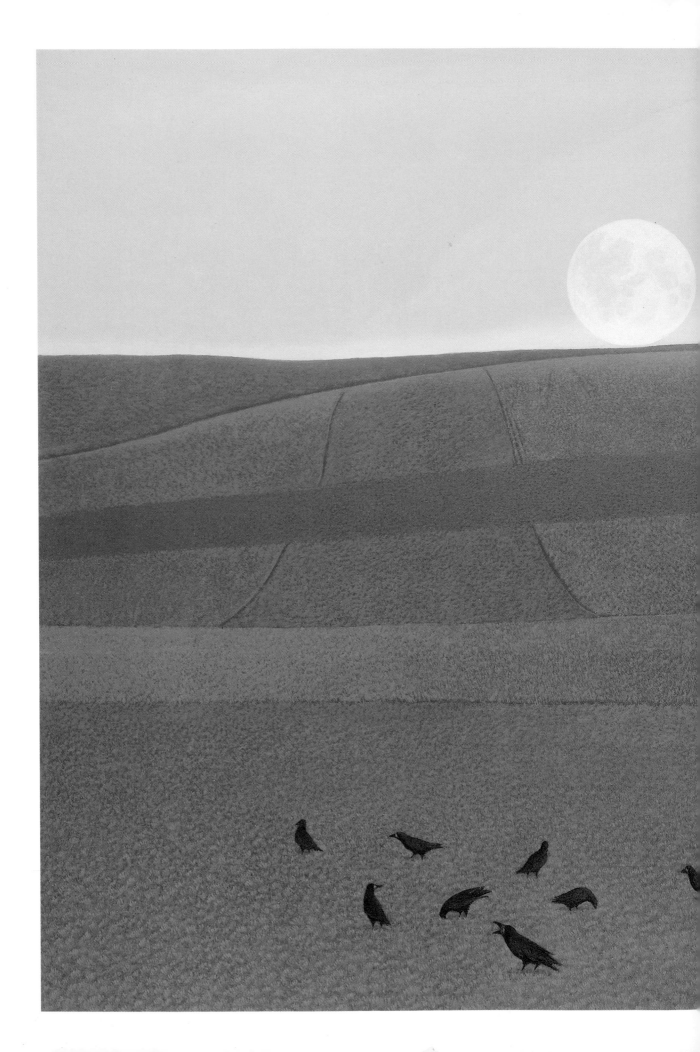

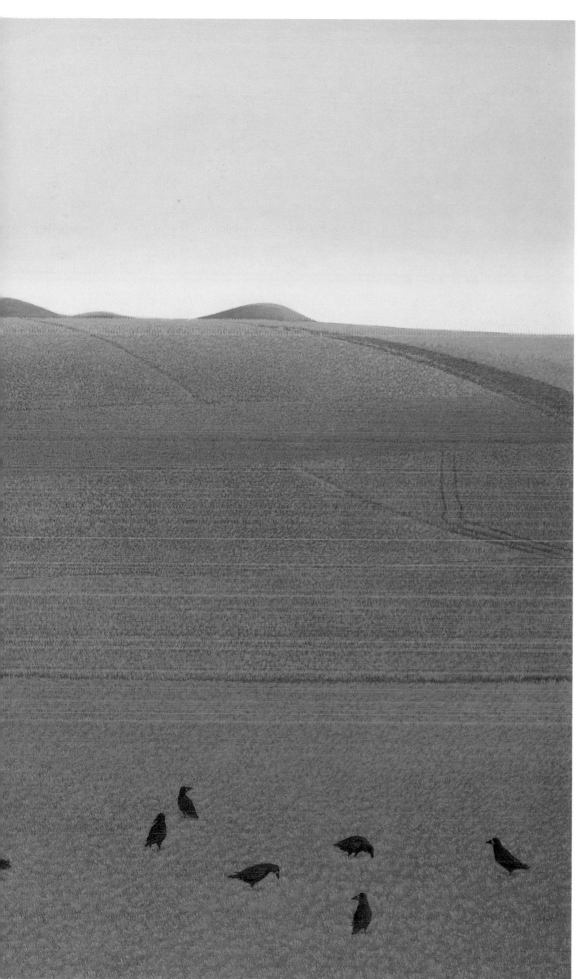

View from Avebury by full moon,
1976, oil, 25.4x35.6cm

OVERLEAF: Portrait of Silbury Hill,
Wiltshire, day time, *1986, oil,
128.2x144.7cm*

Field on fire, Sunset, *1987, oil,
76.2x101.6cm*

Silbury by Night, *1988-89, oil,
40.5x50.7cm*

Figure in the Garden, *1989, oil,
76.2x101.6cm*

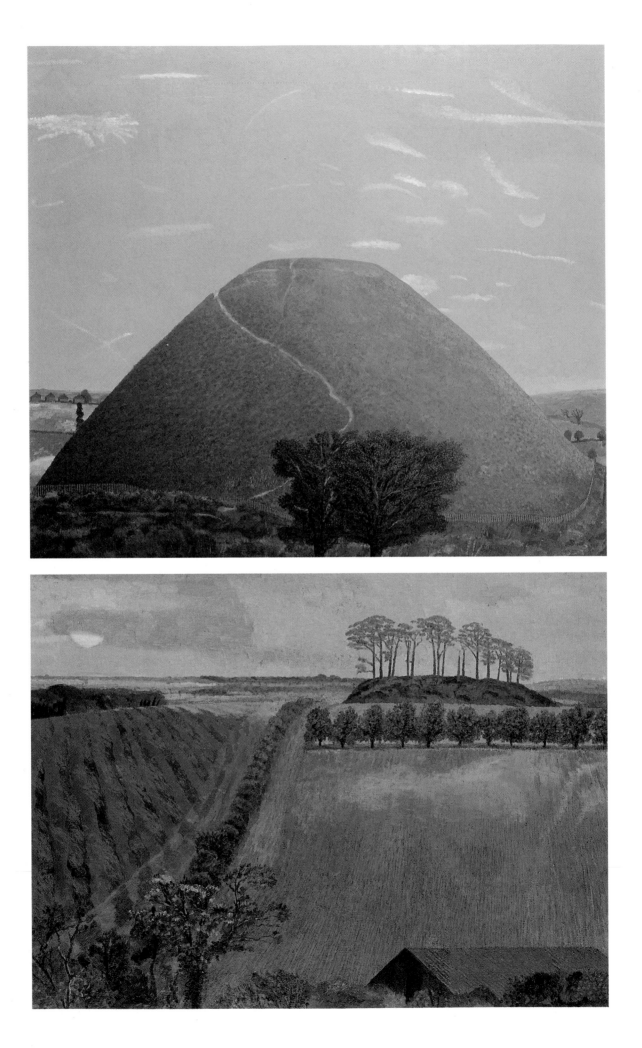

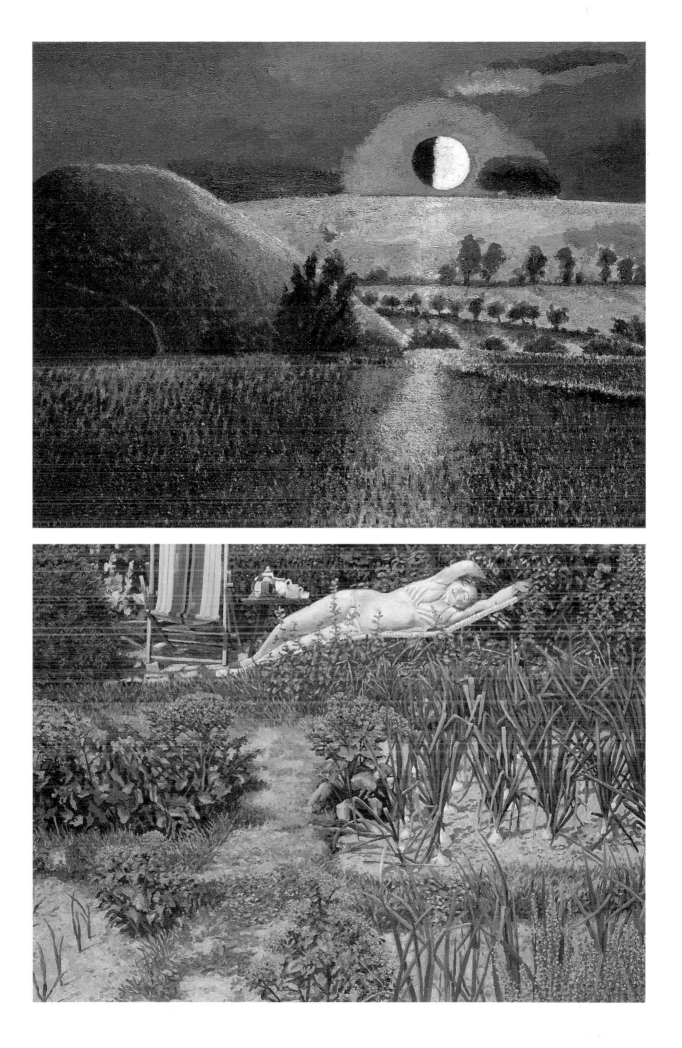

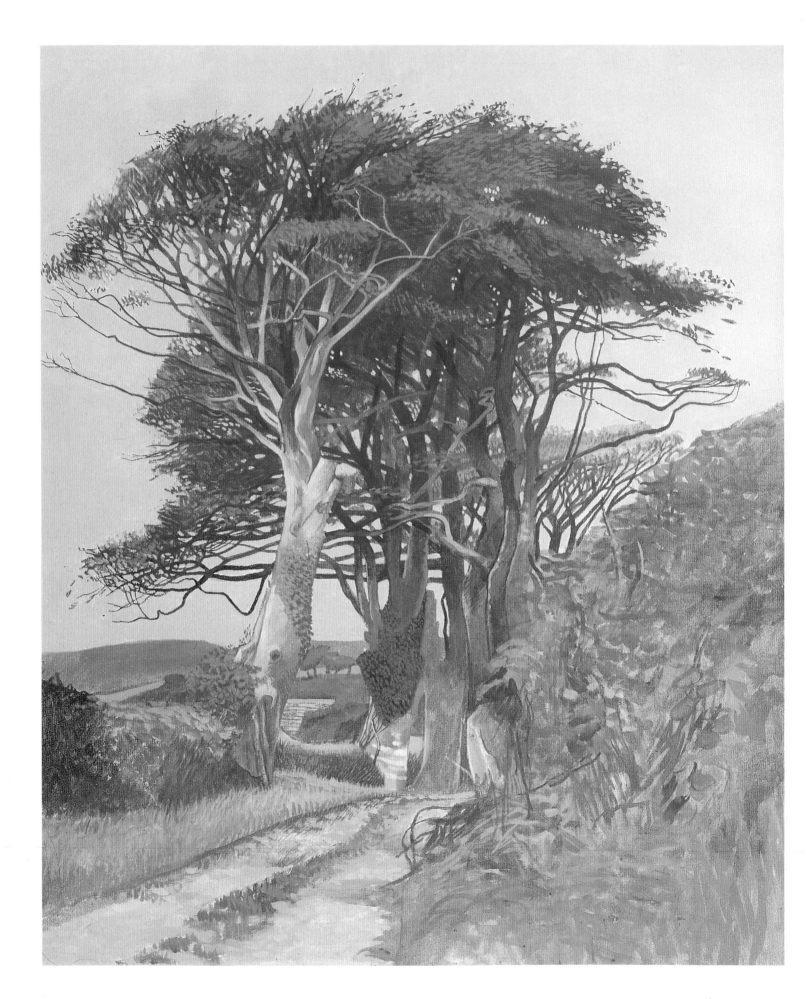

ANNIE OVENDEN

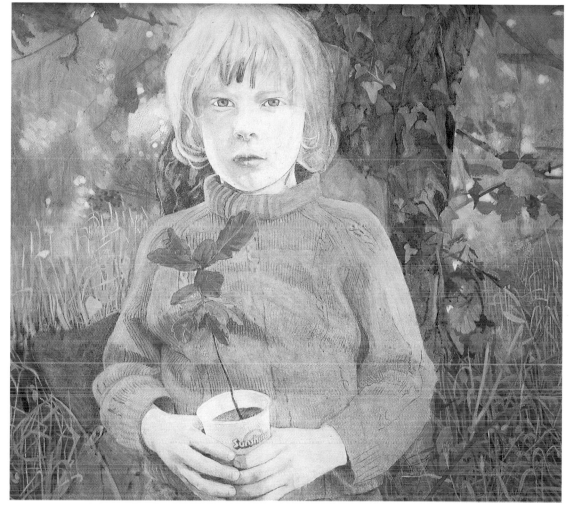

Beeches in Memory of a Friend, *1989, gouache, 76.2x61cm*

Edmund Dante Ovenden, *1976, oil, 61x66cm*

All her paintings, the landscapes and the portraits of her children and her friends' children derive from the practical day-to-day involvement in country life. She is very much the person who looks after the garden, the land, the animals at Barley Splatt, and it is often while doing so that her ideas for paintings come. 'Usually I'll be working outside when suddenly I'll see something in the landscape and then respond to it inside. It is this quality which I've seen the light create, and the feeling I've received from it which I try to put into my painting.'

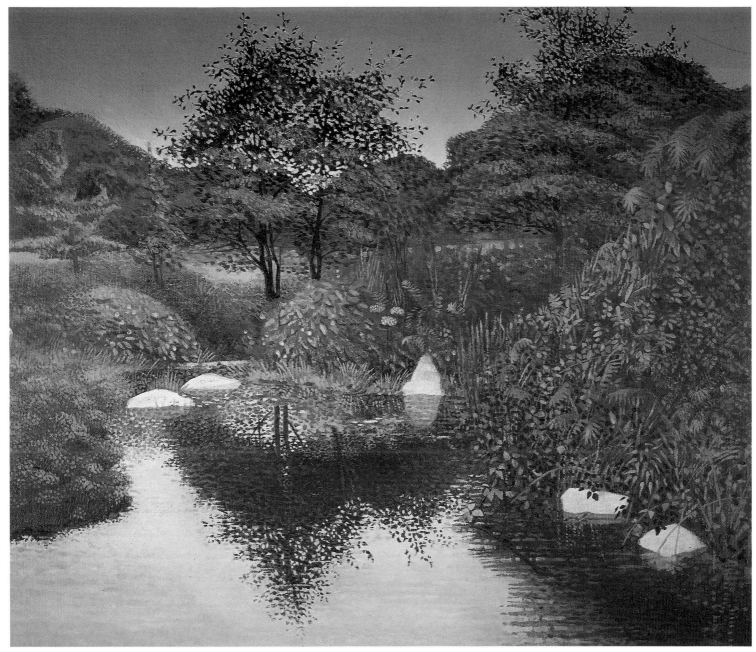

Annie Ovenden, Pond at Barley Splatt, *1988, oil*

ANN ARNOLD

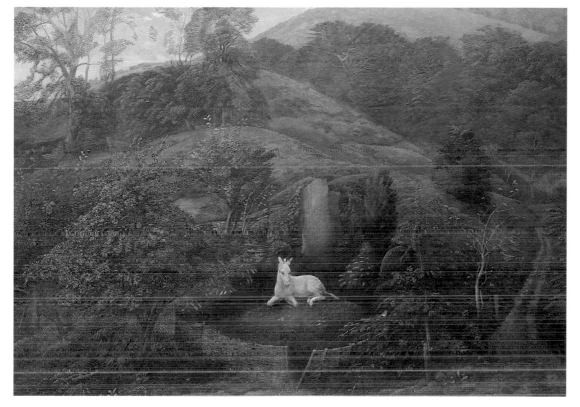

The Sanctuary, *1989, oil*

Ann Arnold is an intuitive painter who works in the tradition of artists inspired by the poetry of the English landscape. The spirituality of places is always present in her work. She paints about her feelings towards people and places with an intensity which recalls William Blake's illustrations to Thornton's *Virgil* or Samuel Palmer's paintings of the Shoreham period. There is also a sense, often present in her work, of fragile balance between individual existence and the outside world. She paints scenes that are very much part of her daily life, but seen at a particular and intense moment. In them, a love of the ritual of life is heightened by a pervading sense of fatalism. *Nicholas Usherwood*

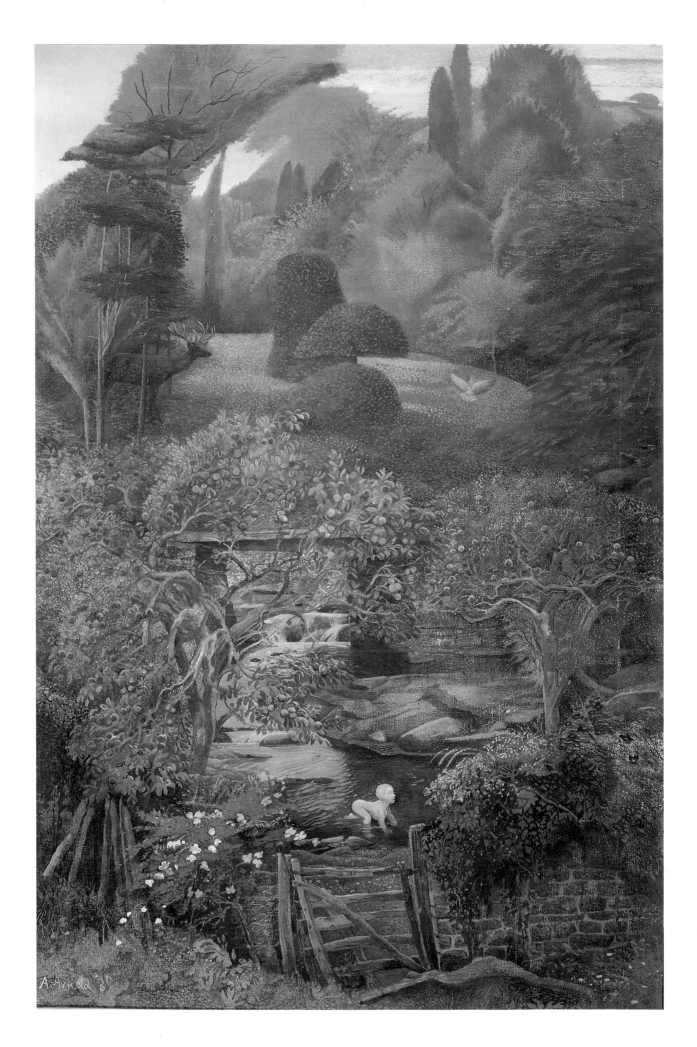

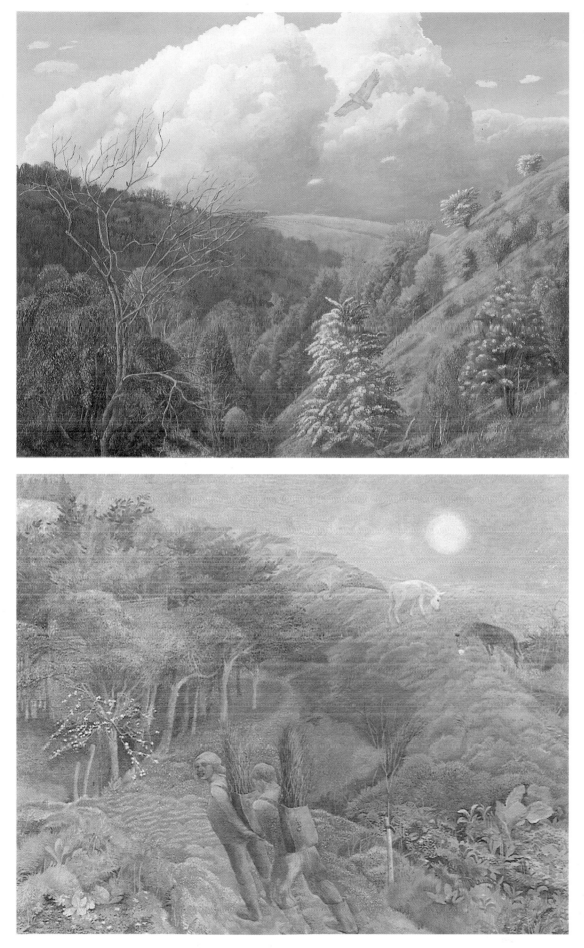

The Secret Garden, *1980, oil*

The Hill in Spring, *1987, oil*

Return to Paradise, *1989, oil*

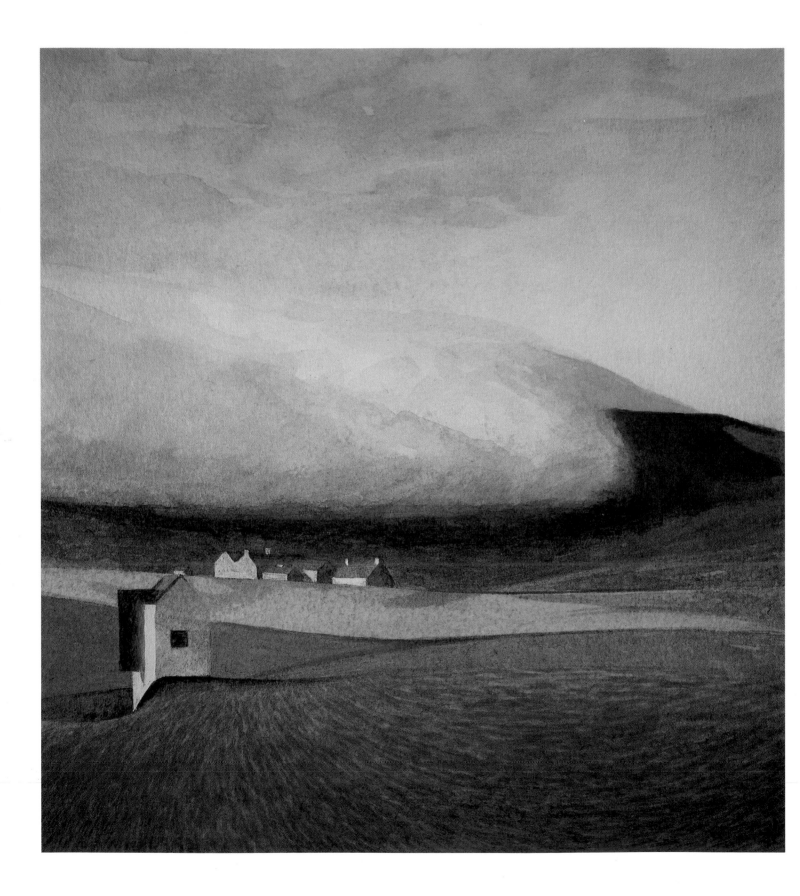

ASSOCIATES

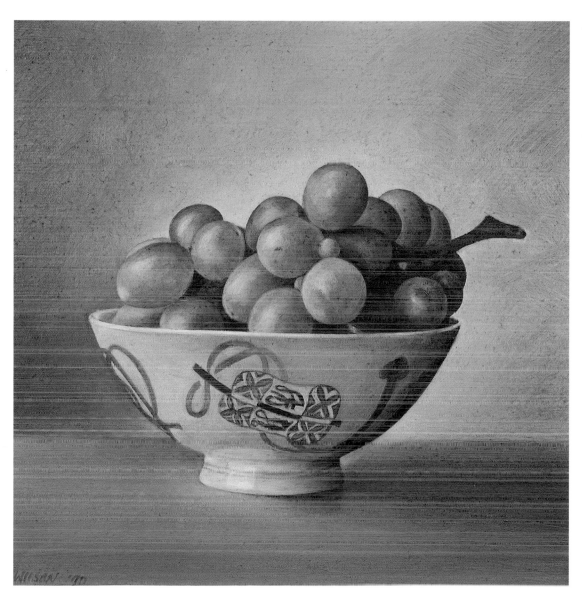

Joseph Hewes, Rousey, 1990, watercolour, 17.8x14cm

Chrissy Blake, Bowl of Grapes

OVERLEAF: Diana Howard, Reading 'Alice' with Reflections, *1990, oil on board, 30.5x35.6cm*

John Morley, His Helmet Now Shall Make a Hive for Bees, *1978, oil on canvas, 117x122cm*

Not numbered among the founding members of the Brotherhood of Ruralists, John Morley, Diana Howard, Brian Partridge, Chrissy Blake and Joseph Hewes nevertheless share many of the sentiments and concerns expressed in the writings and paintings of the movement: above all the reluctance to abandon the traditional techniques of oil on canvas, the resistance to media and concepts that challenge the conventions and limitations of art, and the return to an ideal of romanticism, manifested in paintings of landscapes, gardens, flowers, fruit, etc, combined with a sometimes fantastical imagination that finds expression in book illustration.

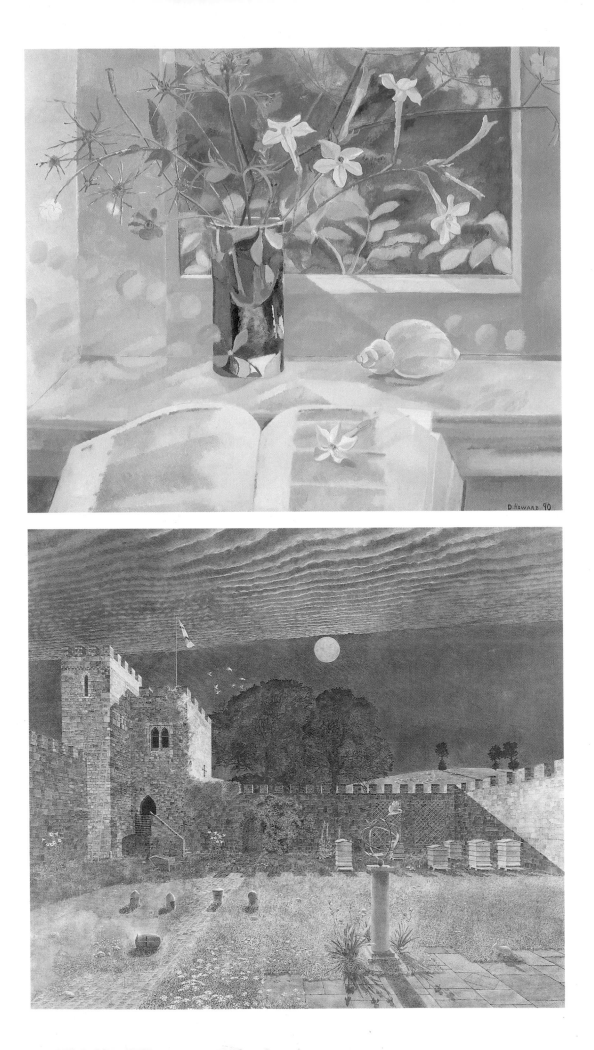